ART AND SPIRITUALITY OF HOLY ICONS

FR. BRENDAN J. McANERNEY, O.P.

View images at: dominicon.com

OAKLAND

DominICON Publications 2021

Copyright © Western Dominican Province, 2020

CONTENTS

Foreword 2

1. Images and the Byzantine Ethos 7

2. Images and the Holy 36

3. Light, Darkness, and Icon Types 71

4. The Grammar, Syntax of Iconography 111

5. Artistic Origins of the Icon 132

6. The Sanctification of Time and Space 153

FOREWORD

Some may think it presumptuous of a Roman Catholic to teach or write about holy icons. Years ago I might have shared that prejudice, but thanks to the generosity of Orthodox and Eastern Catholics who were both teachers and friends, I have come to regard that opinion as simply ill informed. Holy Icons are not principally cultural artifacts, the patrimony of an exclusive ethnic or sociological family. Properly appreciated, they are the property of the Universal Church and materially express belief in the greatest of all mysteries, the Incarnation of Christ God, as affirmed by a variety of Eastern and Western Christian communions. Therefore, the operation and witness of icons is not restricted to the Eastern Churches. However, holy iconography was born in the East and, while not the exclusive inheritance of the Eastern Churches, an appreciation of the spiritual milieu and history in which the tradition of holy icons developed is necessary for anything more than a cursory understanding of its profundity and viability in

our multiethnic, multi-cultural contemporary world.

In 1995 Pope St. John Paul II wrote his Apostolic Letter, *Orientale Lumen (The Light of the East*: Orientale Lumen, Boston: St. Paul Books and Media, 1997) In it he enjoined Latin Catholics:
"Since, in fact, we believe that the venerable and ancient tradition of the Eastern churches is an integral part of the heritage of Christ's church, the first need . . . is to be familiar with that tradition, so as to be nourished by it and to encourage the process of unity in the best way possible for each."

I was personally encouraged because two years earlier, as a Dominican priest, I had begun to study iconography with the Antiochian Orthodox in Pennsylvania and had enjoyed personal instruction from a Greek Orthodox monk, Fr. Nathaniel, who inspired my iconology by locating it within the larger zeitgeist of Christianity as it developed and flowered in the Byzantine East.
Following the Holy Father's letter, I began to share what I had learned about iconography and

the Eastern Churches while I continued to study and serve as a Roman Catholic religious and priest. In 1997 I was granted faculties to serve in the Melkite-Greek Catholic Church, and in 2001 became a priest-in-residence, and then pastor at St. George Melkite-Greek Catholic Church in Sacramento, California until my retirement in 2019.

My service in both the Western (Latin Catholic) and Eastern (Greek Catholic) churches has allowed me to appreciate the histories, hagiographies, theologies and traditions of each, not as competing but complementary expressions of God's presence to His beloved creation through His gift of the Church. Most of the people I have been privileged to teach have been Roman Catholics through a ministry I initiated entitled DominICON.

It was holy iconography that introduced me to the beauty and profundity of the Eastern Churches. It is holy iconography that continues to fashion and direct my ministry as a teacher, consecrated iconographer and priest with one foot in the West and one foot in the East.

Some of my scholarly Dominican brothers may take umbrage at the lack of substantial footnotes in this book. The fact is that much of the information I have comes from disparate sources, Byzantine Catholic and Orthodox clerics and lay people who have related sometimes cultural norms and occasionally esoterica. I have decided to include them all, substantiated or not. I am not a New York Times reporter who must verify any fact with three sources.

This book is not intended to teach one about their faith, but to broaden one's exposure to the Christian faith as it has been lived and celebrated in a particular cultural family that was born in the Greco-Roman world of the Mediterranean and Middle East, preserved and interpreted by the Slavs, that the average "westerner" will find both foreign and familiar.

It is an expansion and clarification of a presentation/course I have offered for some years in parishes, retreat centers and at the Dominican School of Philosophy & Theology, part of the Roman Catholic presence at the Graduate Theological Union in Berkeley,

California. For years I resisted writing a book because the text I used in the class I taught, Linette Martin's, Sacred Doorways, A Beginner's Guide To Icons (Brewster MA: Paraclete Press, 2002) was and remains an accurate, readable and invaluable book.

The information in my book is not revolutionary or theoretical, although I do indulge in some private speculation and reflection. It is not aimed at any narrow demographic. I hope that, like the DominICON Ministry itself, it will make the venerable tradition of Holy Icons more accessible to Western Christians, "so as to be nourished by it."

I wish to thank three men who have proofed and helped me edit this short manuscript: Rev. Michael Fones, O.P., Rev. Augustine Thompson, O.P., Rt. Rev. Mark Melone, and Rev. Reginald Martin, O.P.

Fr. Brendan J. McAnerney, O.P.
Priory of St. Albert the Great
Oakland, California, 2020

View images at: dominicon.com

Chapter 1

IMAGES AND THE BYZANTINE ETHOS

Introduction

Recently, the subject of inspiration versus "cultural piracy " has been increasingly in the news, e.g. "Homage or Theft? Carolina Herrera Called Out by Mexican Minister," The New York Times (June 13, 2019). What may be a revered, centuries old cultural tradition is sometimes appropriated by contemporary artists and designers with only minimal appreciation for the in situ grounding of the tradition. Virtually all art borrows from the past and/or re-interprets legacies. Cultural piracy, however, simply copies wholesale or indiscriminately dissects and willfully appropriates highly valued parts of a tradition, disregarding the consequences or sensitivities of those from whom they steal. A good example is the rock star Madonna's decision to start wearing rosaries as punk jewelry, an offense to many Roman Catholics. Cultural pirates often claim "paying homage" as a rationale for their

exploitation; but the rationale usually rings hollow.

The subject itself is worth considering, but becomes increasingly volatile when referring to artifacts of particular faith traditions. So it is with the history and tradition of Holy Icons as enjoyed principally by the Christian Churches of the East. As I said in my Forward, it is my conviction that, "Properly appreciated (holy icons) are not the property of any specific communion, but are the property of the Universal Church and materially express belief in the greatest of all mysteries, the Incarnation of Christ God, as affirmed by a variety of Eastern and Western Christian communions." I love quoting myself... so insightful.

What is of particular interest to me is to stop, or at least abate, the indiscriminate use of holy icons as decorative elements in either personal or even liturgical settings by persons who do not understand, respect or appreciate the history of holy icons, the many martyrs who died to preserve the holy tradition, and the great love for and veneration of holy icons by Byzantine,

Orthodox Christians. (IMAGE 1/1:1)
Theotokos Enthroned.

Where to start?

We must first recognize that today every person is inundated with images. They are so common that it is virtually impossible to imagine a world without mechanically produced images on screens or in print. It would be all but impossible to count the number of images an individual encounters each day unless one were as removed from "the world " as the monastics of ages past.

It must also be acknowledged that the images we encounter affect us and engender in us reactions as they speak to the human psyche in a gestalt, non-linear manner, often far more powerful than words can describe.

When we think of images we think of things outside ourselves that compete for our attention, but things which we control, either by their intentional incorporation into or exclusion from our lives. As an exercise, pay attention to how these few images affect you. This will take

some real reflection because each of us has a unique history and interaction with images. Consider the importance of images to the artist, the theologian, the poet, the mathematician, the parent, the technocrat and the politician, and how what we say about contemporary images may also be applied to how we will speak about holy icons.

Images allow us to see what has been hidden to mankind through the speed (IMAGE 1/1:2) of the world, size, other factors. (IMAGE 1/1:3) Images tell us what is beautiful in ourselves (IMAGE 1/1:4) and what we consider beautiful in others and what was once considered beautiful (IMAGE 1/1:5)This pin-up photo of Rita Hayworth along with one of Betty Grable (IMAGE 1/1:6) was carried to far away places and into battle by many GIs during World War II to "remind them of what they were fighting for," if not mother and apple pie. Interesting fact: Betty posed with her back to the camera because she was pregnant at the time. It is in contrast to these images, only a few decades old, we can judge how our perceptions of beauty have changed (IMAGE 1/1:7), and how

they are influenced by our shifting societies. (IMAGE 1/1:8)

Images can tell us about secular heroes, (IMAGE 1/1:9) and martyrs. (IMAGE 1/1:10) Images can arouse appetites (IMAGE 1/1:11) of various kinds (IMAGE 1/1:12) , and can be manipulated so as to influence us to desire what we do not have. (IMAGE 1/1:13)
For good or ill, images can play on our emotions. eliciting feelings of tenderness, (IMAGE 1/1:14) outrage (IMAGE 1/1:15) pride (IMAGE 1/1:16), and shame. (IMAGE 1/1:17)

(IMAGE 1/1:18) Images are used to entertain and inform us; and so we enter the image-created "cult of the personality."

Images may give us a glimpse of our common humanity (IMAGE 1/1:19), especially when we can see ourselves from a distance. (IMAGE 1/1:20) . They can simultaneously give us a vision of a unified world, and make us seem very small... lost in the stars. (IMAGE 1/1:21)

(IMAGE 1/2:1) Images, of course, have been around since humans started to depict themselves and their environments many thousands of years ago in pre-history. A common speculation is that such images were a tacit celebration of association with what was depicted and their quasi-magical manipulation of humans and animals. The power of images as evocative, magical, and a means of influencing the natural world, has continued throughout history. Images that disassociate surfaces such as the Fibonacci spiral, (IMAGE 1/2:2) "false" doors in Egyptian tombs (IMAGE 1/2:3) or objects that allow an individual to encounter not a hard surface but a permeable membrane into another dimension exist in both legend and fiction from Alice's looking glass to the Peruvian, gigantic door-like carving on the face of the *Hayu Marca* Mountain, (IMAGE 1/2:4) referred to as *Puerta de Hayu Marca*, which translated into English means, "The Gate to the Gods." One may even regard the newly popular medieval maze or labyrinth as an occasion of mystical peregrination. (IMAGE 1/2:5) , sometimes used as a substitute for a pilgrimage to Jerusalem. (IMAGE 1/2:6)

It is through images, both two and three dimensional, that human beings have for millennia associated themselves with the gods, becoming vehicles, conduits of contact between humanity with the realm of the gods. (IMAGE 1/2:7) Later, when we examine the use of gold in icons we will see that the ancient Egyptians in the Pharaonic cult of the dead believed the gods to have skins of gold, so gilding the face on a sarcophagus indicated association with the celestial beings.

Through this association the mysterious worlds of fertility, life, death, and prosperity were explored, manipulated and propitiated. Heavenly powers were invoked (IMAGE 1/2:8) (*Kherub,* Mesopotamia, c. 3000 B.C.)

(IMAGE 1/2:9) Through images, humanity itself was celebrated in new ways, especially humanity's relationship with the gods, often intimate, sometimes fractious or even hostile . . . the gods as "super-human," (IMAGE 1/2:10) or humanity as god-seeded, with divinity as a destination.

(IMAGE 1/2:11) Ancient images also, occasionally give us a poignant glimpse into the lives of people separated from us by thousands of years, including Sappho, author of the Greek Fourth Tone, known as the "tenth muse," in Pompeii c. 70 AD. Often they seem closer to us in our common humanity than we frequently acknowledge. (IMAGE 1/2:12)

We must make a distinction between images as we encounter them today and the ancient images we have just seen and will explore closely in the tradition of holy icons in Byzantine Christian churches.

Less than two hundred years ago no one had seen a photograph. (IMAGE: 1/2:13) It is only with the industrial revolution that technology advances and makes images of all kinds common.

For our part we must imagine what it was like to see an image in ancient times wrought by an artist. Its production must have seemed almost magical, perhaps even god-like. These are qualities preserved in holy iconography. (IMAGE 1/2:14) Holding that perspective we

may gently approach and embrace the Holy Icon. I love this painting by Theodore Jacques Ralli. The young iconographer sits cross legged as he paints. A small icon tipped against the left leg of the easel may be his inspiration. Three ages of monks are in rapt attention: a young novice, an elder monk seated with his stick, and an adult monk who uses his left hand much as a film director might to concentrate his vision on a part of the iconographer's work. All are entranced, seeing a recognizable figure mysteriously appear on the icon board. Perhaps what they are experiencing is a "material moment of spiritual lucidity," the birth of a holy icon.

In this book we will explore the artistic generation of what we today recognize as images in the tradition of the Eastern Churches, commonly referred to as icons, more properly "holy icons" to distinguish them from other, secular, western images, especially modern (neo-technographic) images. We will also explore the spiritual generation of the tradition of holy icons, especially as it developed through the presence of the Holy Spirit in the Body of Christ, the Church. Here we must

touch on the Ecclesiology common to the Roman Catholic and Orthodox churches, but not always understood in the same way by reformation Christians.

In order to understand the "icon" we will have to become at least conversant with the Patristic focus on the mystery of the Incarnation as seminal to the entire history and tradition of holy images, and the importance of icons in humanity's relationship to God, through the Theanthropos (the God-man Jesus Christ), and the Byzantine world, the "culture" or zeitgeist in which the iconographic tradition was germinated and flourished. We must stop and consider our "western" posture to Byzantine images, so this book is as much about how we see as it is about what we see. What do we see? Are we conscious of the cultural prism through which we encounter these often mysterious images, architecture, gestures, garments and other defining elements of the Christian cultures from the East? Are we willing to allow the possibility that images from an ancient and, in many ways familiar yet alien culture, can teach us about ourselves and our Christian faith?

The Byzantine Ethos

(IMAGE 1/3:1) From the founding of Constantinople as the seat of the Byzantine Empire in A.D. 324 until its fall to the Ottoman Turks in 1453, the worlds of Jerusalem, Rome and Athens met, sparred and ignited, resulting in the most powerful and influential Medieval empire in the world. (IMAGE 1/3:2) It was an empire that dramatically impacted the entirety of Western civilization, Islamic society and culture, and all Slavic communities and their respective histories; Romania being the name associated with the empire by its citizens, not to be confused with modern country that adopted the name Romania on February 21, 1862. Yet oddly, this empire, and its most visible cultural artifact, the holy icon, remains something of a mystery to most westerners.

(IMAGE 1/3:3) Its center was the ancient Greek trading city of Byzantium, renamed Constantinople by the fourth-century Roman Emperor Constantine. It remained so under the Ottomans for nearly six hundred years; but following World War I the newly minted

Republic of Turkey declared Istanbul the city's official name in 1923. Many Eastern Christians continue to refer to the imperial city as Constantinople.

(IMAGE 1/3:4) Present day Istanbul may seem an exotic foreign destination; but any westerner who visits finds it surprisingly familiar. Straddling the Bosporus, it exists in Europe and Asia. It also straddles centuries and empires, Caesars and caliphs, patriarchs and patriots. While the breadth or the Byzantine Empire fluctuated at times, its center was always Constantinople. While imperial influence briefly shifted to Ravenna, it never eclipsed Constantinople.

The Byzantine Empire fused a newly liberated Middle Eastern faith, Christianity, with ancient Greek culture and Roman civic structure.

(IMAGE 1/3:5) But while it was centered in Constantinople, the Byzantine Empire was just that… an empire. It stretched from the border with the Sassanid Empire of Persia to the Pillars of Hercules, The Straits of Gibraltar. It included different ethnicities, languages, tribal

and religious affinities. It struggled through myriad internal conflicts, assassinations, disputations, *coups d'états*, invasions and deliverances. Many would argue that its wealth and sophistication have seldom, if ever, been matched. Within it was born the empire's most visible, encompassing and enduring tradition . . . the holy icon.

"Art", as commonly understood in the west, especially, *ars gratia artis* — "art for its own sake " — the hallmark of late nineteenth century British aesthetes and Pre-Raphaelites, and the motto found on the logo of MGM Studios, did not exist in Byzantium. (IMAGE 1/3:6) Devotional objects such as pectoral crosses, vestments, church mosaics, icons, and illuminated manuscripts were regarded as infused with divine presence, a material reflection of the supernatural world.

Iconography was and is a visual metaphor for the faith, cosmology and civic structure of the Byzantine Empire. That means, to profoundly understand the tradition of holy icons, one must have at least a passing familiarity with what I choose to call the "Byzantine Ethos"; the

social, spiritual zeitgeist that reflects the dynamic and simultaneously reactionary life of the empire.

The "Byzantine Ethos " describes principally the spiritual, mystical tradition of the Eastern Christian churches that grew and prospered in the Empire. It can be vastly different from a westerner's experience and inculturation: (Photis Kontoglou, *Mystical Flowers* , Works 6, 4th ed. (Athens: n.p., 1992), 31 – 42
"So long as Orthodoxy exists in the hearts of people, this aversion (to western scholasticism) will increase as the Orthodox clergy (the genius heads of it) turn to a union with (the) Papacy, a union that will end with the destruction of Orthodoxy and all Christianity as such, leaving faith to be an object of vain scientific observation and equally vain keeping of some customs by the clergy, a living reality in the hearts of only a few, absent from society as such, as happens already in the West. To an Easterner, feeling is more intense than reasoning, while the opposite happens with a European; and since faith regards heart and not reasoning, Easterners are more religious than

Europeans, and thus religions were born in the East, none of them in the West.

Westerners are rationalists, which is why they were devoted to positive knowledge, the sciences, and made a progress there, today leading the whole world to their way. Those among them that make a difference and they don't believe only in their senses, turn to the East, because they discover there a spring to drink, who are thirsty for mysteries beyond the investigation of reasoning."

In a larger context, the ethos of Eastern Christianity is important . . . not simply an "aesthetic" consideration that can be easily challenged or changed by "styles." The ethos, zeitgeist (the intellectual and cultural climate of an era) is fundamentally the material expression of what was and is believed, i.e. that (IMAGE 1/3:7) we are citizens of heaven who can now experience glimpses, eruptions of the divine, the "new heaven and new earth" that are to come (Revelation 21:1), here and now, icons being the most articulate expressions of this faith. (IMAGE 1/3:8) (IMAGE 1/3:9) (IMAGE 1/3:10) as in these icons from St. Catherine Monastery in the Sinai of Sts. Macarius, Elias (Elijah), John Climacus.

This appreciation of the ethos is most beautifully expressed by St. John of Damascus in his Defense of Holy Icons, written in the eighth century during a time in which the very existence of holy icons was challenged by the iconoclasts, those who would remove holy images from all churches, homes and public display throughout the Empire.

"Suppose I have a few books, or little leisure for reading, but walk into the spiritual hospital, that is to say, a church, with my soul choking from the prickles of thorny thoughts, and thus afflicted I see before me the brilliance of the icons, I am refreshed as if in a verdant meadow, and thus my soul is led to glorify God." [Trans. David Anderson (Chrestwood NY: St. Vladimir's Seminary Press, 1980].

I would like to quote a couple of other authors. First, let us take the modern historian Roger Crowley: 1453: [The Holy War for Constantinople and the Clash of Islam and the West (NY: Hachette Books, 2006].

"There was a dark and superstitious side to Byzantium, inherited from ancient Rome and the civilizations of the Middle East that had come under the influence of Rome. A belief in

portents had always been a feature of the life of Byzantium. Constantinople itself had been founded as the result of a mystical sign the vision of a cross that had appeared to Constantine the Great before the crucial battle at the Milvian Bridge 40 years earlier and omens were eagerly sought and interpreted. With the inexorable decline of the empire, these became increasingly linked to a profound pessimism. There was a widely held belief that the Byzantine Empire was to be the last empire on earth, whose final century had started around 1394.

Compare then, the late fourteenth-century Byzantine writer Joseph Bryennios (Quoted in ibidem.):
"We see auguries in the replies and salutations of men. We note the cries of domestic birds, the flight of crows and we draw omens from them. We take note of dreams and believe that they foretell the future . . . it is these sins and others like them that make us worthy of the punishments with which God visits us."

The generation of this dark, superstitious pessimism is not exclusive to the Byzantine

Empire. Much of Medieval Europe shared some of the gloomy outlook. The mystical tradition, however, can be traced directly to Christ God himself, the image of the invisible, ineffable God of the Hebrews. It is to the Jews of antiquity that Jesus speaks when, as recorded by the Evangelist Luke (20: 21 – 26) he addresses the Pharisees who question him. When they question him about paying a Temple tax to the Romans he asks them to show him a denarius. (IMAGE 1/3:11) They quickly produce a coin with the image, icon of Tiberius Caesar on it. The fact that as a matter of course they carried the coin bearing the image of Caesar showed that they lived under Roman sovereignty. When Jesus asks whose image and inscription is on it, they reply, "Caesar's." Jesus' reply is brief: "Then give to Caesar what is Caesar's, and to God what is God's."

To us this may seem a curt and uninspired reply, but to the Jews of antiquity the reply was profound. Every Jew familiar with the Torah, the first five books of the Hebrew Testament, believed to have been written by Moses, knew from the Book of Genesis (1: 27), "God said, In the image and likeness of us let us make man . .

. in His image he created him, male and female He created them." The upshot, of course, is that tenure belongs to the one who has fashioned an image. The coin belongs to Caesar and humanity belongs to God, made and fashioned in God's image.

The question becomes personal when we ask, "To whom do we belong?" If we believe, as revealed in the Book of Genesis, that we are made in the image of God, and that we have new Life in Christ through baptism, how does that belief affect us, not just in the big events of birth, coming of age, marriage, and death, but in our everyday lives?

For the Byzantines, belonging to Christ was a poignant reality. The Empire was a theocracy with an anointed emperor or "Caesar" as its head, representing Christ. This empire was preserved through the establishment of Holy Russia until the first quarter of the twentieth century when Czar "Caesar" Nicholas was assassinated with his family. The empire was understood to be the sanctification of human society and community.

It is worth noting here that when one refers to the Byzantines as a community I do not mean to exclude other communities, antique or modern, that shared some or all of their views and understanding of the world, especially its relationship with the divine.

God-sanctioned governance in the East went beyond what western rulers would claim as "divine right of kings." The Byzantine Emperor was the pontiff, the bridge between God and mankind, the antique Roman Pontifex Maximus . Encouraged by St. Ambrose, the designation was abandoned by emperors because of its pagan connotation, but the title did not disappear entirely. In 590 Pope Gregory I adopted it to signify his role as chief bishop. Although not one of the Pope's official titles, it still appears on buildings, monuments and coins of various popes.

Even absent the antique title of Pontifex Maximus, the eighth century the Emperor Leo III, the Isaurian, regarded himself as both the temporal and spiritual leader of the empire. With this conviction he wrote to Pope Gregory II, "I am priest and emperor." Later Ottoman

sultans would claim to be, "God's shadow on earth," not just temporal rulers.

(IMAGE 1/3:12) The Byzantine emperor regarded himself as the God-anointed bridge between the material and immaterial kingdoms, and was usually depicted with a halo. (IMAGE 1/3:13) Only he blessed with the *dikerion* and *trikerion* (IMAGE 1/3:14) , a practice now reserved to bishops in the Christian East. (IMAGE 1/3:15)

Quoting the nineteenth-century German historian, Theodor Mommsen (Römisches Staatsrecht (Cambridge: Cambridge Univ. Press, 1887):
"The Byzantine Roman Empire was an autocracy with the sanctioned balance of revolution . . . as God shifted His favor blessing from Saul to David, so a usurper to the Byzantine throne may be favored by God. To the victor goes not only the spoils, but the presumption that God approves of his reign. Later, Ottoman sultans became rulers only by defeating any brothers who had equal claim on the throne."

This anticipates the final chapter when we will talk about sacred time (kairos) as a fundamental element of the Byzantine ethos. For now, it is sufficient to say that sacred time is the Kingdom of God as a present as well as future reality, hierarchically presented in the Empire, and in particular through the emperor. As J. M. Hussey remarks ("Introduction," The Orthodox Church in the Byzantine Empire (Oxford Univ. Press, 1986).):

"The Church was not a department of the state. But it was closely integrated into the daily life of an empire which was regarded as being ideally the mimesis or copy of the heavenly kingdom."

Theosis

Before we begin to examine the Sacred Craft of iconography and Holy Icons, their history and construction, we must first ask the question, "Why are holy images used, specifically in the Christian churches of the East?" The answer is at once simple and profound, based on the firm article of faith: the resurrection, transformation and transfiguration of all of God's beloved creation, especially the pinnacle of that

creation, humanity, participating in the very life of God.

In the Latin-speaking West the term used to describe this union with God is called Deification (deificatio) . . . "resurrection of the body, and life everlasting." (Nicene Creed) The author of the second letter of Peter described it as becoming "partakers of the divine nature" (2 Pet 1: 4).

In the Byzantine/Orthodox tradition the union of God and humanity is termed Theosis, "Holy Communion of Nature," θείας κοινωνοί φύσεως. For the Eastern Christian, God is understood to have two modes of existence: His essence (o!σία) and His energies (ἐνέργεια) further explained in Chapter 3 when describing the fourteenth-century theology of St. Gregory Palamas.

The concept of Theosis predates Palamas. It allows humanity to share God's nature but not his essence, which would be pantheism. What the Byzantine distinction attempts to make clear is that deification does not suggest that humanity may become autonomously "gods," but that deification means participation in the life of God. Attributed to the fourth century

saint Athanasius the Great is the assertion that, "God became man so that man might become god." A nice, quotable aphorism, but more correctly, "He (God) became human so that we might be made God," (Greek: Αυτός γάρ ενηνθρώπησεν, ίνα ημείς θεοποιηθώμεν). It is actually much older than Athanasius. It is found in the writings of Clement of Alexandria, Theophilus of Antioch and Hippolytus of Rome.

In the West, deification is accomplished by the Holy Spirit whose activity allows humanity to share, by grace, the essence/nature of God by participation . Thus, one shares by grace what Christ shares with the Father and the Holy Spirit by nature. In Western thought the essence and nature of God are the same, even though Thomas Aquinas defines nature as "the principle of operation of an essence ". In God, who is Being, and who is entirely simple, whose being is His activity, there is no distinction between essence and nature.

The Byzantine East makes a distinction so as to explain theosis in light of the doctrine of Dionysius the Areopagite and Gregory of

Nyssa which culminates in the theology of Gregory Palamas in the fourteenth century. It is apophatic ; a negative way to knowledge of the ineffable, uncircumscribable, uncreated, unknowable, infinite God who is knowable or encounterable only in His effects.

He is present to humanity only in "uncreated energies, " a term used by Maximus the Confessor, borrowed from Aristotelian philosophy where each "nature" has its particular "energy" (*energia*). Note: In Gregory 's theology, distilled from the Fathers, the apophatic (negative) and cataphatic (positive) is held in a tenuous balance (antinomy), resulting in "mystical " spirituality

A.N. Williams explains that for the Latin, deification, the goal of a spiritual life, is anticipated at baptism when one is given the quality of sanctifying grace, and, according to Boethius (Philosopher, A.D. c. 477 – 524), the eternal soul becomes immortal. For the East, theosis begins at baptism and completed in glorification. (A. N. Williams, The Ground of Union: Aquinas and Palamas (Oxford Univ. Press, 1999)

It is the, the reality of theosis that the icon seeks to depict in line, color, and structure using a grammar developed over centuries. Icons mean to show the viewer a transfigured world in which the glorified bodies of Christ and the saints dwell, and through the icon become accessible to the faithful in a particular manner.

Theosis has its foundation in the theocentric anthropology of Genesis, which regards humanity as created in the image of God, and called to the likeness of God. (Genesis 1:26-27) Humanity's "lordship " over the rest of creation is a sign of its royal character given by God and of its destiny to participate in the divine nature (2 Peter 1:4; John 1:12 -13; John 10:34 ; James 1:18; 1 Peter 1:23). Maximus the Confessor tells us:
"This is the blessed end for which all things were created It was with a view to this end, Christ, the hypostatic union of divine and human natures, that God brought forth the essence of all beings." (Quoted in Maximilian Mary Dean, *A Primer on the Absolute Supremacy of Christ* (Bedford MA: Academy of the Immaculate, 2006), 53.)

Ethos is a Greek word originally meaning "the place of living" that can be translated into English in different ways. Some possibilities are "starting to appear ", "disposition " and from there, "character. " From the same Greek root originates the word ethikos, meaning "theory of living, " and from there is derived the modern English word "ethics".

IMAGE 1/3:16) Byzantine iconography seeks to describe the Byzantine ethos, i.e., make visible this Kingdom of God with Christ (IMAGE 1/3:17) as the source and summit of beatitude (IMAGE 1/3:18) The Theotokos is the model for all humanity redeemed, transformed and transfigured by Christ, as is St. Theodosia (IMAGE 1/3:19) in a glorious yet simple icon from early thirteenth-century Constantinople, now at St. Catherine Monastery in the Sinai. She was an iconodule (lover of images) martyr renowned for healing, just one of the myriad of saints, those who "enjoy by grace what Christ enjoys by nature, " i.e., the very life of the Holy Trinity made visible to us in the saints. (IMAGE 1/3:20) (IMAGE 1/3:21) It is this new, transformed and transfigured life that is celebrated and made

visible in icons and the interiors of (IMAGE 1/3:22) Eastern Christian churches in very particular ways, in their structure and in their decoration. (IMAGE 1/3:23)

(IMAGE 1/3:24) It is also made visible in the domestic church, the home, in the collection and display of particular icons. Icons may appear anywhere in an observant home, e.g. St. Euphrosynos, patron of cooks, in a kitchen (IMAGE 1/3:25), or over a bed for protection at night (IMAGE 1/3:26), as seen in the bedroom of Czarina Alexandra in the Alexander Palace. More formally, however, icons are often gathered in an "icon corner,"in Russian a "red corner," (IMAGE 1/3:27) a corner or niche, preferably on an eastern wall, where a candle may be lit, flowers decorate a shelf and other devotional items may be kept. People unfamiliar with icons sometimes wonder why a devotee may have many icons. I usually respond that one cannot have too many friends in the faith.

(IMAGE 1/3:28) The Byzantine Ethos is expressed in an iconographic alphabet and grammar constructed over centuries. It is one

that can be easily taught and learned, but it expresses profound, ineffable truths.

(IMAGE 1/3:29) St. James *Adelphotheos* (Brother of the Lord) (IMAGE 1/3:30), (IMAGE 1/3:31) The Byzantine Ethos… a cultural and spiritual heritage that in its iconography anticipated and experienced an intimate (IMAGE 1/3:32) and ongoing encounter with the divine which leads to a recognition, familiarity, and finally, union (IMAGE 1/3:33) with the Triune God.

Chapter 2

IMAGES AND THE HOLY
The Icon as Sacred Image

Jews request a sign, and Greeks seek after wisdom, but we preach Christ crucified, to the Jews a scandal and to the Greeks folly, but to those who are called, both Jews and Greeks, Christ the power of God and the wisdom of God. (1 Cor 1: 22 – 24)

(IMAGE 2/1:1) "We depict (invisible things) …so that . . . we might have a veiled understanding of them." (St. Dionysius the Areopagite).

One of my new favorite icons is of St. Dionysius with a blue halo. It appears in an article written by the iconographer Fr. Silouan Justiniano writes:
"Let us just pause for a moment, lift up our eyes and see how, "The heavens declare the glory of God' (Ps. 19: 1). It's not surprising, therefore, that the beauty of the azure firmament has for millennia been seen as a symbol of the mystery of the Infinite, the

Eternal, of Heaven itself. Blue, as the 'glory of God," represents the Uncreated Light radiating out from the "divine darkness." The terrestrial manifests the celestial, the temporal the eternal. And since St. Dionysius, the unerring beholder of divine mysteries, is perhaps the most eloquent expositor of apophatic theology, as seen in his Mystical Theology, he bears a blue halo, designating his illumination and knowledge of ineffable realities experienced within the 'divine darkness'". ("Brilliant Darkness: On St. Dionysius the Areopagite's Blue Halo," (Orthodox Arts Journal [website], https://orthodoxartsjournal. org/brilliant-darkness-on-st-dionysios-the-areopagites-blue-halo/ (accessed 7/9/20).

We will explore "darkness, " its mystical and iconographic significance and rendering in following chapters.

All icons may be said to be analogical, wherein by a visible fact an invisible is declared. A particular group of icons may be said to be analogical as they represent hidden or esoteric elements of the Divine Economy, as cited at the end of this chapter.

Yet, we must begin with the obvious. How do we recognize someone? What makes one person unique and distinguishable? Most, I believe, would answer a person's face. While there are billions of people on the planet, I have never met my exact double, twins being excused from this example, although they, too, have differences.

An icon is intended to be an image of the invisible, enhypostasized (en-personed) made visible by a face. There is no such thing as a landscape icon. An icon becomes the vicarious presence of an invisible one, a proxy or mimesis, where one can meet the presence of one depicted by virtue of sharing a face (*prosopon*/personhood) and thus being homonymous (ie. having the same name), an image "recognized" as the one depicted. This association of image and model (prototype) can be best appreciated in a pre-photographic milieu, when the production of a recognizable image must have been seen as nearly magical. (IMAGE 2/1:2) Yet, a vague understanding of the connection between image and prototype can be found in everyday speech. A grandparent may easily display a photograph

and say, "This is my grandson." They mean, of course, this is a photo of my grandson, but the connection between image and person is real.

In the Byzantine tradition the connection is qualitatively different because of the Incarnation of Christ God. We will expand this understanding in Chapter 4. For now we need only to accept that for believers in the Byzantine/Orthodox tradition an icon is more than a picture of someone. An icon shares in the hypostasis of the prototype by likeness of image , specifically the face and is thereby the vicarious presence of the one depicted. Note: hypostasis (Greek) is "that which stands beneath," "person," the inner or objective reality, but not the essence (*ousia*). It is akin to *"prosopon,"* usually translated as "person", but prosopon literally means face, and is the form in which a hypostasis appears. Every nature and every hypostasis has its own proper prosopon, face or countenance, giving expression to the reality of the hypostasis. For further study, I recommend a classic work by Leonid Ouspensky and Vladimir Lossky, *The Meaning of Icons*. (Crestwood NY: St. Vladimir's Seminary Press, 1989).

In the next chapter we will return to the subject of the face, the central component in the sacred craft of iconography through which Christ or one of his saints is portrayed. Now, however, we will regard the face simply as the singular human characteristic that defines a person's individuality in an icon, making that glorified person vicariously present in the material world. Thus, as Pavel Florensky says, the icon is "the boundary that simultaneously separates and joins."

An icon may be said to be a "window" into another reality, the "eighth day of creation," the Kingdom of God... a timeless, eternal, transfigured reality that is accessible to us through the icon... an irruption of the divine into the profane. In this way it is "decorative" as it signifies the church's worship, participation in the heavenly liturgy. The Byzantine Ethos sees the present world as a veiled representation of the eternal , ergo, the Orthodox tradition of regarding liturgical musicians as representing seraphim singing Kaddish, Kaddish, Kaddish (Holy, Holy, Holy); the congregation of worshipers representing the heavenly ranks of angels; the Deacon as an

Archangel leading the angelic choirs as he raises his orarion (stole), the wing of the archangel, to command attention as he directs, "Let us pray to the Lord," fully expecting the choirs to respond, "Lord, have mercy"; the Eucharist as "eating fire," based on Isaiah's description of tongs holding a white hot coal brought to his lips (Is 6: 5 – 7).

In a broad sense, each Christian is to be a living icon of Christ. Humanity is not "true" or "real" except as one reflects the heavenly, for that is humanity's original purpose, created in the image of God . . . to become the likeness of God. Here I quote one of my icon teachers, the noble iconographer and mystic, Vladislav Andrejev (*Prayer and Iconography*, lectures delivered September 3–5, 2004):
"First, when we contemplate the eidos, the "beauty" of the icon, we remain on the surface of the icon. Then, afterwards, we penetrate into the depth of the icon in order that the "meaning" the idea of the icon (can) be revealed to us. This is the Providence of God; His will for me is revealed to me. Since in the mystical life everything is represented by its sphere, even if I go beyond the icon, I return to myself. Then I

see myself as the icon. I AM THE ICON . There is no separation between me and the icon within me, I am within myself and not within the icon . . . my own icon within begins to live and develop within my self. This is why this state is called "contemplative, " because after this state the contemplation, my life as icon begins. This is not life as preparation to become icon, or preparation for life. *This is real, true and authentic life, as life within God.* In the East, this intimacy with God is theology."

Although this small reflection might just as well be included in the following chapter under the rubric of "The Artistic Evolution of the Icon, " it may be useful to insert the Byzantine concept of "originality " here, as it differs dramatically from our usual Western understanding of what constitutes an "original work of art " when speaking of a holy icon. Every icon, with the exception of the "image made without hands" *acheiropoietos*, • χειροποίητος, the Holy Mandylion (IMAGE 2/1:3), all icons have a material origin. St. Luke (IMAGE 2/1:4) is reported to have painted the first *Hodegetria*, Directress icon, showing the Theoto kos holding her Divine Son on her left

arm and pointing to him, hence the title which means, Directress, or She Who Points the Way. (IMAGE 2/1:5) There are many icons of the Hodegetria attributed to St. Luke in our modern world. Can they all be "originals " from his hand? . . . certainly not.

But are they "originals " in the Byzantine ethos? . . . yes! Icons reproduce themselves through the hands of iconographers, they come into existence through the sacred craft. They are not properly "invented, " but born afresh, renewed . . . each, an original.

Please note in this image that the *maphorion* (mantle) of the Theotokos breaks the border of the *kovcheg* (recessed area in the middle of the panel). The image irrupts into the material world.

This tradition begins with Christ God himself in the icon known as the Holy Mandylion, also known in Greek as *acheiropoieton,* image "made without hands ". (IMAGE 2/1:6) This image by Theophanes of Crete, f r o m Stavronikita Monastery on Mount Athos, is a clear example. There are variations in the

tradition, but the basic legend is that King Abgar of Edessa, now in southern Turkey, was suffering from a skin malady and heard of a wonder-working Jewish rabbi named Jesus. He sent a royal delegation to Jesus asking him to travel to Edessa so that he might be cured. Jesus, busy tending to the House of Israel, refused the invitation but after having bathed his face pressed it to a *mandylion*, kerchief, and an image of his face was transferred to the cloth. One can easily see how this legend and the Shroud of Turin and the Veil of Veronica (an anagram of "Ver-icona," true image) and the Holy Mandylion have become entangled.

St. Jude Thaddaeus, a "brother of the Lord" in the Eastern tradition, accompanied the royal delegation when they returned to King Abgar (IMAGE 2/1:7) who venerated the image and was healed. This is why the a Roman Catholic statue of St. Jude (IMAGE 2/1:8) shows him wearing a medallion inscribed with the face of Christ, representing the Holy Mandylion. Some time later, to protect the mandylion, it was hidden in a tiled niche within a wall. When (IMAGE 2/1:9) it was recovered years later it was discovered that the image had reproduced

itself on the ceramic tiled surface of the niche, and was subsequently titled, The Holy Keramion (Κεράμιον) or Keramidion (Κεραμίδιον), that is, the "Holy Tile." In a fully decorated Orthodox, Byzantine Church one may often see at the eastern base of the central dome the icon of the Holy Mandylion (IMAGE 2/1:10) and facing or near it (IMAGE 2/1:11) the icon of The Holy Keramion.

The purpose of this pious legend is to illustrate that Holy Icons reproduce themselves, sometimes miraculously, more often through the hands of devout iconographers. Each may be considered in the Byzantine ethos an "original." Note: Tourists in the East often do not understand the difference between an icon labeled "hand made," usually a print attached to a board with hand-painted lettering, and "hand painted," which means exactly that. In addition, the icon of Our Lady of Guadalupe (IMAGE 2/1:12) is considered by many to be another icon "made without hands," although recent scholarship questions the pious legend of its origin.

A quick note about St. Jude Thaddaeus is necessary. In the Eastern tradition, St. Joseph was a widower with children when he was espoused to the young maiden Mary. This is why in formal iconography he is not depicted as a young, vigorous man, but as a man with gray hair. The only traditional icon representing the Holy Family is the "Flight Into Egypt," where a young man, James *Adelphotheos* (Brother of the Lord) another son of Joseph and later the first bishop of Jerusalem, is seen (IMAGE 2/1:13) accompanying Mary, Joseph and Jesus on the journey into Egypt, leading or following the donkey on which the Theotokos and her divine son ride. (IMAGE 2/1:14) An icon of St. James "the Lesser," to distinguish him from James the son of Zebedee, resides in the Monastery of St. Catherine in the Sinai.

Theological Evolution of the Icon

We shall consider the artistic development of the Icon in the next chapter, but to understand what it is we are looking at, we must explore the theological evolution of the icon.

In the early Church, icons were used much as we use photographs, to stir memory of

sanctified men and women of the past, especially as icons were easily moved unlike the sarcophagi of early saints and martyrs where typically Christians gathered in their memory. In addition, there was the antique Roman idea of the vicarious presence of the one depicted. This was certainly true in statuary. Romans did not worship statues, but the gods they represented, allowing that the god might be present through his or her depiction.

The best example of this belief was in the use of the *lauraton* in a Roman court, a rondelle with an embossed or carved image of the Emperor that signified his judicial and moral presence in the court. (IMAGE 2/1:15) In addition, there was the common belief in many Mediterranean cults, especially Egyptian, of communication with the dead through an image. We will explore this concept further in Chapter 5.

For nearly 100 years, beginning in the mid-eighth century, in the midst of an energetic if challenged Byzantine Empire, the venerable tradition of holy icons went through a period of Passion, Death and Resurrection. Known to

historians as the "Iconoclastic Controversy," it was an often violent, critical, spiritually voluptuous epoch that formed and solidified Eastern Christianity in ways unparalleled in the West until, perhaps, the Council of Trent in the sixteenth century, convened in response to the Protestant Reformation.

Many Latin Catholics may view the "controversy," which was less a disagreement than a rapacious, often bloody and lethal quarrel, as tangential to the Catholic- Orthodox faith we enjoy today, only because they are unfamiliar with the tradition of holy icons in Orthodox and Eastern Catholic Churches, and the Second Council of Nicaea's influence on the Council of Trent in the sixteenth century that codified the importance of images.

(1 Cor 1: 22 – 24)
Jews request a sign, and Greeks seek after wisdom, but we preach Christ crucified, to the Jews a scandal (Greek: *skandalon*) and to the Greeks folly (Greek: *morian)*, but to those who are called, both Jews and Greeks, Christ the power of God and the wisdom of God.

The "scandal" to which St. Paul refers is the Semitic abhorrence of an "immanent," mundane God, a sentiment shared by all non-sacramental Christian denominations and Islam. Judaism embraces anointed prophets and a Messiah, but finds offensive the idea that the ineffable God of the Hebrews would choose to be anything other than transcendent; that He would choose incarnation and muck about in a clearly untidy creation; that He would make Himself perpetually accessible to sinful humanity in a sullied creation through "sacraments," using material such as bread, wine, oil, and water. But St. Paul posits that the response of God to the Jews' request for a "sign" is the "power" (Greek: *dynamin*) of God, by which he means that Jesus Christ is the substantial and perfect image of the invisible God. Where he is, there is the uncreated and saving grace of God, made present to humanity through the Incarnation. This "power" is not external to God, not something that God possesses . . . it is God, not in His essence, but in His energies, as interpreted in the fourteenth century by St. Gregory Palamas.

What is less obvious to Western Christians is the profound theology that supports and has defended the tradition of icons. While images have always been a part of the Church, beginning with figurative paintings on catacomb walls, it was not until the use of icons was disputed in the eighth and ninth centuries that theologians examined, clarified and canonized the tradition.

The Controversy

An army commander (Greek: *strategos*), Leo III, the Isaurian from southeastern Turkey, became Emperor of the Byzantine Empire in 717 by overthrowing Theodosius III. (IMAGE 2/1:16) He reigned for nearly a quarter century, put an end to a period of instability, and temporarily defended the empire against the invading Umayyad Arabs, the second of four Islamic caliphates established after the death of Mohammed, with its capital in Damascus. But Islam was on the move. The year of his ascension to the throne Leo had to defend Constantinople itself from attack by the Umayyads. Having thus preserved the Empire from extinction, Leo proceeded to consolidate its administration, which in the previous years

of anarchy had become badly disorganized. He also undertook a set of civil reforms in an attempt to return the Empire to the splendor it enjoyed during the Age of Justinian three centuries earlier. During and after his reign the following dates are important.

721 : Caliph Yazid II of the Umayyad Caliphate, chief rival of the Byzantine Empire, destroyed icons as blasphemous, a draconian action that set a precedent for future iconoclasm. Many Christians continued to live "under the yoke" of Islam as they do to this day. Some accommodated and lived peacefully with their Muslim neighbors in what is termed the *dhimmitude,* usually enduring special taxes and curtailed civil rights.

725: Three bishops from Asia Minor under protection of the emperor destroy icons in their dioceses. Leo III, demonstrating his ecclesiastical authority as anointed emperor, preaches in Hagia Sophia .

Most importantly, he issued a series of edicts against the creation, use and veneration of images (726 – 729). He received the support of

the official aristocracy and some of the clergy, but a majority of the theologians and, conspicuously, the monks opposed his decrees with uncompromising hostility, often resulting in savage brutality against iconographers and other iconodules. In the western parts of the empire the people simply ignored or refused to obey the edict. As the Controversy heated up Emperor Leo III ordered all icons to be destroyed, then seized reliquaries, vestments and church plate throughout Constantinople and destroyed them publicly. Pope Gregory II wrote to him acidly, commenting that he should leave church doctrine to those qualified to compose it. I have previously cited the Emperor's haughty reply that he regarded himself as both Emperor and priest. In addition, however, the Emperor sent two warships to arrest the Pope. Fortunately, they foundered at sea.

No doubt, his motivation had a number of components including a genuine desire to improve public behavior by challenging a deep-rooted Byzantine tendency to superstition, inherited from ancient Rome, which resulted in some idolatrous use of icons, including icon

paint chips being crushed into medicinal potions. In addition, according to accounts by Patriarch Nikephoros and the chronicler Theophanes, the eruption of the volcanic island of Thera (Santorini) and military reversals against the Umayyads may have been viewed by Leo as evidence of the wrath of God brought on by image veneration.

In addition, as explained by J. M. Hussey in her book, The Orthodox Church in the Byzantine Empire ((London: Oxford Univ. Pres, 2010).), while the Church was not a department of the state, it was closely integrated into the daily life of an empire which was regarded as being ideally the mimesis or representation of the heavenly kingdom. Leo, like other emperors saw himself as more than a temporal ruler, as illustrated in his letter to Pope Gregory II. He understood himself to be the spiritual leader of the Empire, divinely appointed by God... the Pontifex Maximus, in the old Roman tradition, through whom God made His will known and realized.

In Constantinople the religious traditions of Jerusalem, the legislative and organizational

strengths of the Roman Republic and its later emperors, and the philosophical and artistic heritage of Athens met, contested and combusted, creating one of the most powerful, vibrant and influential Medieval empires in the world. If an emperor was deposed it was assumed that God's favor had shifted to the new occupant of the imperial throne. But while he occupied the Great Palace, the emperor was the God-appointed Caesar, whose hierarchical authority mirrored the authority of God Himself. While this Neo-Platonic paradigm may seem distantly removed from our contemporary, egalitarian society, we should be reminded that it survived into the twentieth century, until the death of Czar (Caesar) Nicholas II of Russia in 1918.

Whatever his prerogatives and incentives, Leo introduced a period of internecine conflict out of which an Orthodox veneration of holy icons would emerge, a tradition which has advanced through periods of flowering, pruning and "renaissance," one which continues to define the spirituality of Eastern Christians to this day. The attack on a long established, traditional reverence for holy icons became the occasion

for a response that solidified and canonized the devotion. The Iconoclastic Controversy and the resulting Second Council of Nicaea, while initially driven by military-political as well as theological considerations, had the effect of coalescing "orthodoxy."

The defenders of Holy Icons believed that iconoclasts demeaned the doctrine of the Incarnation, Christ's two inseparable natures, defined by Ephesus in 431, giving Mary the title Theotokos, and the "hypostatic union," two distinct natures in one person (Christ — true God and true man), as defined by the Council of Chalcedon in 451.

Here are some conciliar dates worth noting as we move to untangle the basic theological debates of the Iconoclastic Controversy and its resolution:

325: Council of Nicaea I: Condemns Arianism (Jesus fully human but not fully divine). In 381 the Council of Constantinople definitively declared the divinity of Christ and equality of the Holy Spirit with the other two persons, completing the Creed.

431: Council of Ephesus: Declared Mary as Theotokos — condemned Nestorianism (Christ had two separate natures, fully human and fully divine). 451 Council of Chalcedon — Christ has two natures in one person.

553: Council of Constantinople II: balances Antiochian (human/historical) and Alexandrian (divine/mystical)
theologies of Christ.

680 : Council of Constantinople III: condemned monothelitism, affirming that Christ had both human and divine wills that functioned in perfect harmony, neither consuming the other.

St. John of Damascus and St. Theodore the Studite

The first and principal theologian to defend holy icons in a widely admired polemic was St. John of Damascus. His writings and the pious traditions that surround his life are quintessentially "Byzantine."

The contesting and ultimately victorious argument put forth by him, St. Theodore the Studite and St. Nicephorus of Constantinople hinged on the mysterious reality of the Incarnation.

In Damascus, under the protection of the Umayyad Caliph Marwan, he wrote the seminal, On The Divine Images . His argument is relatively simple. The legitimacy of a holy image is founded on the Doctrine of the Incarnation. The interdiction against images in the Second Commandment: "You shall not make for yourself a carved image, or any likeness of anything that is in heaven above, or that is in the earth beneath, or that is in the water under the earth; you shall not bow down to them nor serve them. For I, the Lord your God, am a jealous God " is superseded, not contradicted or removed, by God Himself in the material Incarnation of the Second Person of the Trinity, the "image of the invisible God " (Col 1: 15) In the Incarnation, as Jesus himself says, "He who has seen me has seen the Father." (Jn 14: 9) One may say, with judicious legitimacy, that the Triune God, in a Trinitarian act, perichoresis, uses Christ as the model for

the face of Adam, the first son of God in the flesh. (IMAGE 2/1:17) (Capella Palatina, Palermo, Sicily) "Let Us make man in Our image and likeness."(Genesis 1:26) While some Christian denominations consider that original image fatally flawed by the sin of our First Parents (Original Sin), the Orthodox communion considers the imagery compromised, but not extinguished. From the Orthodox Evlogitaria of the Dead:
"I am the image of Your ineffable glory, even though I bear the wounds of sin. Look with compassion on Your creature, O Lord and purify me in Your mercy . . . O Lord, who with Your own hand have fashioned me from nothingness, and adorned me with Your Divine Image, and who, when I transgressed Your commandment, did cast me down into the dust whereof I had been made. Deign, O Lord to restore me to Your likeness, that my original beauty may be renewed in me."

The iconography of the Capella Palatina in Palermo, Sicily is not only beautiful but instructive. (IMAGE 2/1:18) It was the royal chapel of the Norman kings of Sicily situated on the first floor at the center of the Palazzo

Reale in Palermo, Sicily. Also referred to as a Palace church or Palace chapel, it was commissioned by Roger II of Sicily in 1132. The iconography is purely Byzantine, but the Old Testament cycle (IMAGE 2/1:19), which runs along the side walls of the center aisle in two registers follows in the tradition of Roman church decoration, and the inscriptions are in Latin, as befitted Norman rulers.

In the creation of Adam (IMAGE 2/1:20), he is pictured in a recognizable paradigm of Jesus. "He who has seen me has seen the Father." (Jn 14: 9) The naked Adam into whom God breathes life also looks like Jesus. Another characteristic of classic iconography, which will be discussed later, is so evident here that it must be noted. All the animals that God brings before Adam so that he may name them and thereby accept "dominion " over them, seem to be floating. They are not balloons but exist in a flat space and are thereby rendered pedagogic. Naturalism, in terms of space, is rejected in favor of iconographic purity that informs the viewer that he/she is viewing the spiritual reality recorded in Genesis, Adam and Eve discovered in their nakedness (IMAGE 2/1:21),

and are driven from the Garden (IMAGE 2/1:22).

St. Theodore the Studite affirmed that the prototype is not essentially in the image, rather the prototype is in the image because the icon "shares" in the hypostasis (person- hood) of the prototype and therefore is signified by being homonymous , called by the same name. It is his conviction that when an icon is presented it is not simply an "image" of the one depicted; it is the one depicted, made materially visible through the tradition of Holy Iconography.

St. John and St. Theodore prepared for the establishment of the iconographic tradition as we know it today by declaring belief in what would be approved by Nicaea II (787), the doctrine of the Incarnation and the doctrine of Two Natures of Christ, i.e., union without confusion of divinity and humanity, the hypostatic union. Ergo, to paint Jesus is to paint the eternal Logos , as the two natures are indivisible, as neither consumes the other, as in the heresy of Monophysitism. The relation between creator and creatures is forever changed. In one of the most beautiful passages I have encountered St. John of Damascus

writes (*Three Treatises on the Divine Images* (Crestwood NY: St. Vladimir's Seminary Press, 2003):
"I do not worship matter; I worship the Creator of matter, who became matter for my sake, who willed to take His abode in matter, who worked out my salvation through matter."

On this faith rests our Catholic and Orthodox veneration of images and sacraments.

Contemporary scholarship occasionally impacts long held ideas about a particular historical episode. Such is the case when examining the Iconoclastic Controversy. To acknowledge a new perspective on the subject I include the following.

In his essay, "A Dark-Age Crisis: Aspects of the Iconoclastic Controversy," Peter Brown contends that the Iconoclastic controversy was a debate on the position of the holy in Byzantine society:
"Almost all scholars regard the Iconoclastic Controversy as, endogenic, a crisis within Byzantine Christianity itself," not a reaction to the iconoclasm of Islam or Judaism. At its heart he regards the Controversy as a struggle to

differentiate the profane from the holy. There were three undisputed occasions of holiness in the Empire: the consecrated Eucharist, the church building, basilica consecrated by a bishop with its solemn association with the Temple in Jerusalem, and the sign of the cross, as a gesture and as a physical object. But a tendency to venerate images had always been a part of Mediterranean cultures, and icons of Christ and the Theotokos were passively accepted early. The three undisputed occasions of holiness were compromised in the seventh and eighth centuries by the increased devotion to individuals, unconsecrated holy men. A *geronta*, γέροντας (Greek), was and remains an elder , a local holy man gifted with the charism of spiritual direction, often a monk or hermit, but not necessarily a priest. Monastic piety was the piety of the Byzantine layman writ large." (In Society and the Holy in Late Antiquity (Berkeley: Univ. of Calif. Press, 1982).

Holiness was slowly extended to the images of these holy men after their deaths. Iconoclasts regarded the broadening of devotion and veneration of holy men and their icons as a

breach in the wall that separated the visible world from the divine. The Iconoclast bishops meant to definitively repair that fracture during the Council of Hieria (A.D. 754), but the Council was later rejected as an illegitimate Ecumenical Council by the Second Council of Nicaea in A.D. 787. Brown goes on to say that the Byzantine Christian belief in intercession and the need to focus on the person, especially the face, of the intercessor expanded the value of the what became the holy icon, as the power of God was understood to overshadow the icon. "Filling the gap between awesome holy things and the frail believer . . . [the] icon . . . became a chosen vehicle for expressing the majestic rhythms of the divine plan of salvation." Personal piety employing icons as intercessory instruments expanded devotion to local "saints," and eroded dependence on the great churches and even the Eucharistic liturgy that had become distant, formidable and rarefied. Widespread veneration of icons opened the Iconodules to accusations of idolatry, the perfect fodder for reformist zeal. By asserting that only a limited number of symbols (Eucharist, consecrated church, cross) were holy, Iconoclasts supported a more collective

and centralized, established hierarchical order of society, breaking the growing unofficial power of the holy man/monk, and the icon.

Brown concludes that argumentation over what was genuinely holy or profane, particularly icons and the resulting locus of authority, constituted the warp and woof of the Controversy.

Sacred Craft

The Orthodox understanding allows that an iconographer is acting in a semi-sacerdotal (semi-priestly) manner as he or she brings an image into existence. Like a priest the iconographer may be said to share in the work of the "pontifex," to be a bridge builder between the material and immaterial worlds, but only as a member of the Body of Christ, the Church, never separated for an egocentric expression of self. Holy iconography is the property of the Church, but the vocation is specific, to preach the Gospel in line and color and is hence, a Sacred Craft.

Here a comparison to the Eucharist and holy relics may be useful. In the consecration of the Eucharist, grace transforms the substance of the bread and wine into the Sacred Body and Precious Blood of Christ himself. If a portion of the Eucharistic bread is broken into two pieces, neither piece ceases to be the Body of Christ. If a piece of a holy relic is removed, each piece, large or small, continues to be a holy relic because grace attends the physical matter. Specifically for St. Theodore the Studite, an icon is different. For him, if an icon is sufficiently defaced so as to be no longer recognizable as an image of Christ or one of His saints, it ceases to be an icon because it no longer shares in the *prosopon*, personhood, of the one depicted. Grace does not attend the wood, the gesso or the paint used in the construction of an icon.

Resolution of the Controversy

Finally, we must address the resolution of the Controversy, delayed in its full implementation, but setting the bedrock foundation for the Tradition of Holy Icons that will develop,

flourish, be pruned and continue to flourish into our own time.

787: The Council of Nicaea II: against the iconoclasts, last of the Seven Ecumenical Councils recognized by the Orthodox East. Nicaea II did not create a new devotion, but clarified and solemnly canonized the established tradition of sacred images. In the Seventh Session (October 13, 787), the council issued a declaration of faith concerning the veneration of holy images:
"As the sacred and life-giving cross is everywhere set up as a symbol, so also should the images of Jesus Christ, the Virgin Mary, the holy angels, as well as those of the saints and other pious and holy men be embodied in the manufacture of sacred vessels, tapestries, vestments, etc., and exhibited on the walls of churches, in the homes, and in all conspicuous places, by the roadside and everywhere, to be revered by all who might see them. For the more they are contemplated, the more they move to fervent memory of their prototypes. Therefore, it is proper to accord to them a fervent and reverent adoration, not, however, the veritable worship which, according to our

faith, belongs to the Divine Being alone, for the honor accorded to the image passes over to its prototype, and whoever venerate the image venerate in it the reality of what is there represented." (Decrees of the Ecumenical Councils , ed. Norman P. Tanner (Washington: Georgetown Univ. Press, 1990), 1: 137 – 38.)

Two particular words are used by Nicaea II that are worth noting. *Latria* ("worship "): paid to God alone, and *Proskynesis* ("veneration" not "worship") paid to icons and those transfigured in Christ. Not unlike the veneration showed to the Torah by Jews, especially as it is processed, touched and kissed.

802: Irene of Athens: Even though her husband was an iconoclast, Empress Irene of Athens harbored iconophile sympathies. During her rule as regent, she called the Second Council of Nicaea in 787 and brought an end to the first iconoclast period (730 – 787). As Empress Regent of the Byzantine Empire she was overthrown by Emperor Leo V, the Armenian, when she attempted to implement the conclusions of the Second Council of Nicaea. Irene 's unprecedented status as a female ruler

of the (Byzantine) Roman Empire led Pope Leo III to proclaim Charlemagne emperor of the (Holy Roman Empire) on Christmas Day of 800 under the pretext that a woman could not rule, and so in his judgment the throne of the Roman Empire was vacant. A revolt in 802 overthrew Irene and exiled her to the island of Lesbos; supplanting her was Nikephoros I.

815: Emperor Leo V, the Armenian, instituted a second period of Iconoclasm in 815, again possibly motivated by military failures seen as indicators of divine displeasure.

843: Empress Theodora, widow of Emperor Theophilus, became regent for the minor heir, Michael III in 842.

Unlike Irene 50 years earlier, she successfully presided over the restoration of icon veneration. On March 11, 843, as directed by the Second Council of Nicaea, she and Patriarch Methodius returned Holy Icons from the Church of Blachernae to Hagia Sophia in Constantinople. (IMAGE 2/1:23) Since that time the first Sunday of Great Lent has been celebrated in the Orthodox and Byzantine Catholic churches

as the feast of the "Triumph of Orthodoxy," and "The Sunday of the Holy Icons," respectively.

In the West there was no substantial controversy about religious images until the Protestant Reformation, when the "scandal" of God immanent in creation, as referred to by St. Paul, was once again reinvigorated by the Protestant Reformation to which the Roman Church responded with The Council of Trent, 1545 – 1563, Session XXV, quoting Nicaea II: "The holy Synod enjoins on all bishops . . . that images of Christ, the virgin mother of God and the other saints should be set up and kept, particularly in churches, and that due honor and reverence is owed to them, not because some divinity or power is believed to lie in them as reason for the cult, or because anything is to be expected from them or because confidence should be placed in images as was done by the pagans of old, but because the honor showed to them is referred to the original (prototype) which they represent; thus through the images which we kiss and before which we uncover our heads and go down on our knees (*dulia*), we give adoration to Christ and veneration to

the saints, whose likeness they bear. And this has been approved by decrees of councils, especially the second council of Nicaea, against the iconoclasts."

Following 843

After 843 artistic canons interpreting the theology of the Councils began to develop and direct iconography and a more theological, supra-rational, mystical iconographic alphabet and grammar began to develop. From the crucifixion of the Controversy, the resurrection of a vigorous canon of iconography begins to develop and is forevermore regarded as the inheritance of the Church.

Chapter 3

LIGHT, DARKNESS AND ICON TYPES

Before we begin examining some icon types, it is necessary that we understand two iconographic elements that will play a recurring part of in many of the icons we encounter, Taboric Light and Luminous Darkness. What follows is a short theological treatise, but seminal to the mystical, fundamental and distinctive characteristics of holy icons.

Taboric Light

Taboric Light in Byzantine/Orthodox theology is not a metaphor but the uncreated energies of God , in which God communicates Himself and reveals Himself to those who have purified their hearts. This light (*phos*) or illumination (*eggampsis*) surpasses intelligence and the senses, but fills the intellect and the senses, manifesting itself in the total man, not just one of his faculties. It is called "Taboric Light " because it is identified with the light that shone from Jesus during his Transfiguration on what

is traditionally accepted as Mount Tabor, and is iconographically rendered as Luminous Darkness. For the Eastern Christian, God is understood to have two modes of existence: His essence (ο"σία) and His energies, (ενέργειες), further explained below when describing the theology of St. Gregory Palamas. The uncreated, eternal, divine and deifying light is grace (χάρις) given to us and accomplishing deification, to make us "partakers of the divine nature" θείας κοινωνοί φύσεως *(divinae consortes naturae)* (2 Pet 1: 4). It is more substantial than Gothic light that merely penetrates and illuminates; it is transformative. It effects and denotes participation in divine beauty-goodness, that which is *kalokagathic*, a Greek word that means both beautiful and good.

Note: This is contrary to the Western understanding of grace as created by God as a material help for mankind, and the term "uncreated" as in uncreated grace (*gratia increata*) can refer only to God in the Person of the Holy Spirit.

(IMAGE 3/1:1) In an icon there is no natural or material light. Divine light suffuses, infuses and illuminates all of the "new creation," the transformed and transfigured universe. John the Baptist with wings? He is the Forerunner, messenger, in Greek, *angelos*, which is also translated as angel, so wings are a sign of his ministry. (IMAGE 3/1:2) Objects and especially human bodies glow from within and cast no shadows as there is no material light, as exemplified in the bodies of Sts. Zosima and Mary of Egypt. The absence of material light is also seen, or rather not seen, in the absence of any glassy reflection in eyes. So, Taboric Light becomes part of the iconographic lexicon.

(IMAGE 3/1:3) Practically, an iconographer begins with the pigments of the lowest value and then lightens them layer by layer in an attempt to represent the material world transfigured by Taboric light. In the hands of a master iconographer the result can be startling, a doorway or window into divinized reality.

Note: The three components that describe a color were codified in the late nineteenth century by Albert Munsell in his *A Grammar of*

Color (New York: Van Nostrand Reinhold, 1969), (IMAGE 3/1:4) Hue — color, i.e. red blue, yellow, etc.; Chroma — relative intensity of color: bright / gray; Value — relative light/ dark, i.e. white / black.

Luminous Darkness (*Photeinou Gnophou*)

This language is an oxymoronic metaphor, first used by St. Gregory of Nyssa in the fourth century to describe the experience of the ineffable, incomprehensible Divine Being who is indeed Beyond Being and Beyond Thought; not the ineffable itself. Clumsily identified in apophatic, negative terms, God as unknowable, ineffable, uncreated, etc.

Iconographically, when luminous darkness is used to identify eternal, divine and deifying light in a specific interaction with the material world, it is traditionally rendered in a manner that is the opposite of natural light. The best example of natural light is, of course, the sun. A painter uses his/her brightest color to indicate the bright- ness of the sun, then increasingly darker colors moving away from the sun. (IMAGE 3/1:5) For luminous darkness the

opposite is employed. The center of luminous darkness is the darkest pigment, not black, but darkest. (IMAGE 3/1:6) Moving from luminous darkness the pigments become increasing light in value.

Divine Darkness — a Short Treatise

Light and Darkness have long been used metaphorically representing good and evil, especially by the Evangelist John: "God is Light, and in Him there is no darkness." (1 Jn 1: 5)

However, darkness has also been used as a metaphor of Divine Presence.

Clement of Alexandria (circa A.D. 150 – 216) uses the term "darkness" (*gnophos* or *skotos*) to signify the transcendence of the Father. He then tells us that, "starting with the majesty of Christ" one proceeds "through holiness" towards the abyss (*bathos*) of God-Who-Contains-All (*pantocrator*), knowing God apophatically, negatively, not in what He is but in what He is not.

For Gregory of Nyssa (fourth-century Cappodocian Father), intimacy with God goes beyond "vision" and transforms the idea of vision (*theoria*) into a meaning closer to the Hebrew ידע *(yada')*, "to know," which is beyond intellectual apprehension, but expresses an existential relationship where knowledge vanishes and only love (*agape*) remains. Intimacy with the divine is a genuine *ekstasis*, a "going-out" of the intellectual state. This is symbolized by "darkness, luminous darkness," as experienced by Moses (Ex 24: 15 – 18), and revealed in Psalm 17 (18).

Dionysius the Areopagite (fifth century) brings us fully into Byzantine theology for his doctrine of the dynamic manifestation of God, implying a distinction between the unknowable "essence" of God and His "processions" *dynameis* or energies (ενέργειες), later used by Gregory Palamas, serve as a dogmatic basis for Orthodox theology.

Dionysius' conceptual structure can also be seen in his system of signs which is also a structure of analogy. Even though Dionysius calls God "sun" and "light," he is quick to

balance with the negative, cataphatic / apophatic (oxymoronic) "luminous darkness," which is more appropriate to God's existence.

St. Gregory Palamas (A.D. 1296 – 1359), Archbishop of Thessolonika, is best know for his defense of the Hesychasts of Mt. Athos against the attacks of the Italo-Greek monk Barlaam of Calabria. While the West has viewed Gregory as an innovator, the East sees him squarely in the Orthodox Tradition, applying it vigorously.

His is a mystical theology that has as its goal turning the spirit from abstract notions about God, to the experience of divine realities. No finite knowledge can fully know the Infinite One, and therefore, He is only truly to be approached by agnosia, or by that which is beyond and above knowledge.

St. Gregory underscores a point of doctrine inherited from St. Basil, St. John of Damascus and other Fathers, namely that God is understood to have two modes of existence: His essence, ουσια and His energies, ενεργειες. Essence is entirely unknowable; God's

energies, however, can work in synergy with human energies. God's energies are not effects, they are the natural procession of God Himself, a mode of existence which is proper to Him, an overflowing of His essence, manifestations of His personal force. The best example I have heard is that of a sword thrust into a fire (God's essence) until it is glowing red. When the sword is removed from the fire and touched to tinder, the tinder will catch fire. The sword is not fire, but carries the energy of fire to the tinder.

For the East it is not God's essence that will be contemplated by the saints in the world to come, but the face of the living and personal God revealed in Jesus Christ. God's energies do not flow from the Father exclusively, but from the Trinity, and these energies lead all to the life of the Trinity, which the Gospels call the Kingdom of God.

St. Gregory did not regard The Transfiguration as a manifestation, but a revelation. A change was produced in the consciousness of the apostles who received for a moment the ability to see their Master as He was. By a

transmutation of their senses the disciples passed from flesh to the Spirit and became one with the Light and their corporeal senses were transcended. The Taboric Light was the uncreated energies of God that affected the transmutation. This is why St. Gregory moves from using the word energy to using the words "divine light," mystical experience, the visible character of divinity, Taboric Light. It is a theology for those who belong more to the future life, the eighth day of creation, than to the present earthly life.

The uncreated, eternal, divine and deifying light is grace, χάρις, given to us and accomplishing deification, to make us "partakers of the divine nature " θείας κοινωνοί φύσεως [*theias koinonoi phuseos*] *divinae consortes naturae* (2 Pet 1: 4).

Incarnate grace can only be received as such in contemplation, *theoria*. Contemplation is not a passive reception but requires the dynamism of the Spirit. The light of God must therefore be assimilated in order to be transmitted to others, hence the Dominican tradition of contemplata aliis radere, to share the fruits of one's

contemplation. Man thus enters into the divine eros . The knowledge of the intelligible light becomes illumination, and therefore man moves toward the luminous darkness of absolute mystery.

The challenge to iconography was and is how to graphically render this theology, this mystery.

Types of Icons

To my knowledge there is no common division of icons into types. For my own sense of order I have developed what some may view as arbitrary categories, but they serve to organize my otherwise disparate panoply of images. Many icons fall into more than one type, and new "types" may aid more precise organization.

Portrait Icons
Perhaps the easiest type of icon to identify is the portrait image of an individual. It should be noted here that eastern iconography, unlike western iconography, is not replete with symbolic artifacts that aid the western viewer in

identifying the one depicted, e.g St. Lucy holding a plate with detached eyeballs (IMAGE 3/1:7), or St. Andrew with a saltire. (IMAGE 3/1:8) While such symbols do appear in eastern iconography, especially in Narrative icons, in Portrait icons they do not have prominence. (IMAGE 3/1:9) The glorified person has pride of place, and to reduce confusion, the name of the one depicted is written on the face of the icon, so while St. Lucy is wearing a virginal white tunic and holding a martyr's cross, she is identified by her name clearly written on the face of the icon. So too, St. Andrew is identified by his name. (IMAGE 3/1:10)

(IMAGE 3/1:11) Jesus Christ is usually shown with two names, properly always in Greek, illustrating his two natures, human and divine: ις xς the first and last letters of ιησο.ς χριστ.ς "Jesus Christ, " his human nature, and ὁ ὤν in Greek the translation of, ἐγώ εἰμι ὁ ὤν, "I am Who Am (the Being) " Exodus 3:14, his divine nature as revealed to Moses.

(IMAGE 3/1:12) The Theotokos is identified by M P ΘY, also properly always in Greek, the first and last letter of the Greek Μήτηρ Θεού,

"Mother of God." The title Theotokos, God bearer, was confirmed by the Council of Ephesus, AD 449.

Narrative Icons
These icons recount historical events in the life of Christ, the Theotokos and the saints, including the Festal Series depicting the twelve great Feasts of the Church, recorded here in historical order, not liturgical order as one may see by the festal dates for fixed feasts. Each icon is accompanied by a *kontakion*, a type of thematic hymn originally an extended homily in verse. Here it is worth explaining that orthodox hymnology is not decorative or evocative as is much western liturgical music. Instead it, like Orthodox iconology, is theological. If one encounters a festal icon and its meaning seems obscure, one needs only listen to the kontakion sung by the cantor and the meaning of the icon is made evident.

Festal Icons

Note: For the past twenty-five and more years I have relied on a set of festal icons from Holy Transfiguration in Brookline, Massachusetts. In

addition to being beautiful, they are entirely orthodox in their construction and very clear in their particulars; so I have chosen to include one of them in each of the following descriptions as clear illustrations of narrative icons.

In these and other icons we will have the opportunity to be exposed to many elements of the iconographic "alphabet" and grammar that will be expanded upon in the following chapters.

The Nativity of the Theotokos, celebrated on September 8th. (IMAGE 3/1:13)
Kontakion (κοντάκιον — a liturgical festal hymn that originated in the Byzantine Empire in the sixth century):
By Your Nativity, O Most Pure Virgin,
Joachim and Anna are freed from barrenness;
Adam and Eve, from the corruption of death.
And we, your people, freed from the guilt of sin, celebrate and sing to you: the barren woman gives birth to the Theotokos,
the nourisher of our life!

(IMAGE 3/1:14) In this icon we see St. Anne reclining after giving birth to the Theotokos. It is a graphic scheme that will be repeated in the icon of The Nativity of the Forerunner (John the Baptist). As we look at various icons we should begin to discern harmonies and resonances between icons and themes.

Unlike the previous icon, the Theotokos is not depicted as an infant but rather a small version of her adult self. It may be difficult to see in this icon, more easily seen in the previous icon, but the identifying MP ΘY appears on her cradle right above her halo. Also difficult to see, but very evident in other icons, are the three jewels she wears, one on her forehead and one on each shoulder, standing for her perpetual virginity before, during and after the birth of Christ.

The Presentation of the Theotokos, celebrated on November 21 (IMAGE 3/1:15).
Kontakion:
The most pure Temple of the Savior;
the precious Chamber and Virgin;
the sacred Treasure of the glory of God,
is presented today to the house of the Lord.

She brings with her the grace of the Spirit,
therefore, the angels of God praise her;
truly this woman is the abode of heaven.

In this Melkite icon we see a protracted version of the pious legend that includes not only her presentation to her uncle, the High Priest Zachariah, but also her being fed with heavenly food, manna , by the Angel Gabriel while resident in the Temple, as recorded in the Infancy Gospel of James, *Protoevangelium Jacobi*, a non- canonical but highly influential book.

Two scenes happening simultaneously is part of the iconographic grammar that we will explore in the next chapter.

(IMAGE 3/1:16) In the Holy Transfiguration Monastery version the virgins accompanying the Theotokos, again depicted as a small adult, are prominent along with her parents Anna and Joachim.

The Annunciation, celebrated on March 25
(IMAGE 3/1:17)
Kontakion:

To You, the Champion Leader of Triumphant Hosts do I ascribe thanksgiving offerings of victory for from terrors you have delivered me, O Theotokos and as You possess the power invincible do You free me from every kind of danger that I may cry to You, Hail, O Bride unwedded.

Here we see Holy Doors through which only a priest steps to either present the Gospel or the Eucharist to the faithful. It is traditional to have the Annunciation on the Holy Doors along with icons of the four evangelists.

In this icon the Virgin holds up her right hand indicating her question, "How shall this be done to me as I do not know man?" We will see an alternative gesture in the next icon. Note the posture of the Angel Gabriel. His feet are apart signifying movement; he is not standing still. He holds up his right hand in a gesture of locution not blessing. He would never presume to bless the Theotokos. Rather, his gesture signifies his greeting, "Hail, full of grace, the Lord is with you." From "luminous darkness " descends a shaft indicating the descent of the Holy Spirit. Note the red drapery hung on

architectural elements an iconographic theme showing that the event is taking place inside a building.

(IMAGE 3/1:18) In this contemporary Russian icon the posture of the Virgin is different. She bows her head indicating her response, "Let it be done unto me according to your word."

(IMAGE 3/1:19) In this final icon of the Annunciation, note the clear writing on the face of the icon identifying the event, the Angel Gabriel and the "Mother of God." Now her three jewels can be clearly seen as she sits on a queenly throne, her feet shod in royal resting on a platform so that she remains elevated.

The Nativity of Christ God In The Flesh / Christmas, December 25 (IMAGE 3/1:20)
Kontakion:
Today the Virgin gives birth to the Transcendent One, and the earth offers a cave to the Unapproachable One! Angels with shepherds glorify Him! The wise men journey with a star! Since for our sake the Eternal God was born as a Little Child!

A great deal is taking place in this icon even though it seems placid. The Theotokos reclines on a mat, that some say is a Jewish traveling mat, something like a sleeping bag. She appears in front of a cave, painted in black that represents unredeemed creation into which the Christ has been born. Next to her is the Christ Child wrapped in swaddling clothes which are evocative of funeral wrappings. He is in a manger, from the Latin *manducare*, to eat, closer to the Italian *mangiare* . The manger, resembles both a sarcophagus and an altar from which the "Bread of Life," the Eucharist, is distributed. The ox and the ass near the manger represent the Hebrew and Christian testaments. "The ox knows his owner, and the ass his master's crib." (Is 1:3)

From above, a shaft with a star descends from luminous darkness and is watched by adoring angels. To the right, a shepherd blows a trumpet in rejoicing. From the left come three magi, identified as foreigners, i.e. not Greeks, because they wear Phrygian caps, associated in antiquity with several peoples in Eastern Europe and Anatolia, including Phrygia, Dacia, and the Balkans.

In the lower right we see the child Jesus again, now being bathed. The story that attends this incident is as follows. One of the attending women, Salome, decided to probe the Virgin to ascertain if she was still virginal. For her presumptuous audacity her arm was withered. While bathing the infant, a prefigurement of baptism, her arm was restored.

On the lower left we see the figure of Joseph looking very glum. An old man, in profile which identifies him as a minor figure or an evil figure, is speaking to him. In New England we used to call him "Old Scratch," better know as Satan, not Lucifer, but the satan, the adversary whom Jesus will encounter during his earthly life. He is saying to St. Joseph, "Virgin birth?... ridiculous. We all know how babies are made." This reflects an ancient heretical belief, sometimes attributed to Jewish opponents of Christianity, that the Virgin was raped by a Roman soldier named Pantera. In a traditional icon the Virgin is looking at St. Joseph with benevolence, or at the viewer, pictorially affirming the love and support of the Church for all those who find the dogma of the Virgin Birth difficult to accept. As with all icons I

discuss, I suggest the reader do some additional research to identify parts of the iconographic pedagogy that I may miss. An old but reliable source is *The Meaning of Icons* by Leonid Ouspensky and Vladimir Lossky (Crestwood NY: St. Vladimir's Seminary Press, 1989).

(IMAGE 3/1:21) Here we see the same elements, but the withered arm of Salome is made obvious as well as the star and the angel's announcement of the birth to the shepherds.

The Presentation of Jesus In The Temple, celebrated on February 2 (IMAGE 3/1:22) Kontakion:
By Your nativity, You did sanctify the Virgin's womb, and did bless Simeon's hands, O Christ God. Now You have come and saved us through love. Grant peace to all Orthodox Christians, O only Lover of man!

(IMAGE 3/1:23) Here the Hebrew and Christian testaments meet in the person of Christ, the Theotokos, St. Joseph who carries two sacrificial doves, the venerable prophetess Anna and the prophet Simeon who holds the

divine child in his arms, reciting the *Nunc Dimittis*:
Now, Master, you let your servant go in peace. You have fulfilled your promise. My own eyes have seen your salvation, which you have prepared in the sight of all peoples, a light of revelation to the Gentiles, and the glory of your people Israel. (Lk 2:32)

Again, the swagged drapery tells us that the scene is enacted inside the Temple.

The Baptism of Christ — Theophany / Epiphany, celebrated on January 6 (IMAGE 3/1:24)
Kontakion:
Today You have shown forth to the world, O Lord, and the light of Your countenance has been marked on us. Knowing You, we sing Your praises. You have come and revealed Yourself, O unapproachable Light.

This lovely icon was painted in the Monastery of Stavronikita on Mt. Athos by one of my favorite iconographers, Theophanes of Crete, in the sixteenth century. After fathering children he became an idiorrhythmic monk, one

following his own pattern of monastic life and prayer, who along with his sons painted the entirety of Stavronikita giving contemporary iconophiles and iconologists a unified scheme of decoration rarely seen. Jesus has waded into the Jordan. From luminous darkness above a dove descends while John the Baptist reaches out a hand to touch Jesus. Angels in attendance cover their hands in a sign of reverence. They are not holding Jesus' clothes, as some have erroneously supposed.

(IMAGE 3/1:25) In this icon one can more clearly see an axe entwined in a stump or small tree, the figures of *Jordanus* with a fish tail and *Thalassa* riding a porpoise (Jordan River and the Sea), and Jesus is walking on dry ground trampling vipers, reminiscent of the Jordan drying up for the Ark of the Covenant to pass. (Jos 3:17) The priests carrying the ark of the covenant of the Lord stood firm on dry ground in the middle of the Jordan, while all Israel crossed over the dry ground, until the entire nation had crossed the Jordan.

Other Scripture quotations illuminate cryptic parts of the icon:

(Mt 3:1):
There shall come forth a Rod from the stem of Jesse, and a Branch shall grow out of his roots. The Spirit of the Lord shall rest upon Him, the Spirit of wisdom and understanding, the Spirit of counsel and might, the Spirit of knowledge and of the fear of the Lord. (Is 11:1 – 2)
For now the axe is laid to the root of the trees. Every tree therefore that does not yield good fruit, shall be cut down, and cast into the fire.
(Ps 113):
What ails you, O Sea, that you fled? O Jordan, that you turned back? O mountains, that you skipped like rams? O little hills, like lambs? Tremble, O earth, at the presence of the Lord, At the presence of the God of Jacob.
You shall tread upon the asp and the basilisk: and you shall trample under foot the lion and the dragon. Because he hoped in me I will deliver him: I will protect him because he has known my name. (Ps 90)

The Transfiguration, celebrated on August 6 (IMAGE 3/1:26)
Kontakion:
On the Mountain You were Transfigured,

O Christ God, and Your disciples beheld Your gloryas far as they could see it; so that when they would behold You crucified, they would understand that Your suffering was voluntary, and would proclaim to the world, that You are truly the Radiance of the Father!

One of my favorite icons, The Transfiguration, is replete with obvious and enigmatic figures and symbols. First we notice Christ standing before an aureole of luminous darkness. In some icons the luminous darkness takes on a variety of shapes, including a shape that suggests butterfly wings. In Greek the title of this icon is Metamorphosis, μεταμόρφωση or *metamórfosi*, of which the most poignant example in grade school is a caterpillar who is turned into a butterfly. This analogy is problematic in that, as St. Gregory Palamas makes clear in his homily 34, "because the great vision of the light of the Lord's transfigurations the mystery of the eight day, that is of the age to come," and "The Light of the Lord's transfiguration does not come into being . . . rather, at that moment the disciples (Peter, James and John) 'passed from flesh to spirit' by transformation of their senses, which

the Spirit wrought in them." *Byzantium / Modernism: The Byzantine as Method in Modernity* (Leiden: Brill, 2015), 342.

In accord with St. Gregory 's analysis, the disciples have halos indicating their new, if brief, mystical sight. On Christ 's right stands the Prophet Elias who was taken bodily into heaven and so did not die. He stands for the living and the prophets. To Jesus ' left is Moses, properly rendered as beardless, not with a Charlton Heston flowing beard, but holding the tablets of the Law, standing for the dead and the Law.

(IMAGE 3/1:27) In this rendering of the Transfiguration by Theophan the Greek, divine darkness touches each of the disciples, but no halos; and Moses has a very short beard. Note: On the left we can see Jesus leading his disciples up the mountain, and on the left leading them down. In both cases he is turned toward them, preparing them and teaching them about his journey to Jerusalem and his ultimate sacrifice.

(IMAGE 3/1:28) In this Holy Transfiguration Monastery icon we again see a suggestion of wings, Moses has a short beard, the disciples are not directly touched by luminous darkness and have no halos, but the inscription, Holy Transfiguration, Metamorphosis is clearly seen.

Entry into Jerusalem or Palm Sunday (IMAGE 3/1:29)
Kontakion:
Sitting on Thy throne in heaven, and carried on a foal on earth. O Christ God, accept the praise of angels and the songs of children who sing, Blessed is he who comes to recall Adam!

(IMAGE 3/1:30) We must remember that between the Transfiguration and his entry into Jerusalem Jesus broke his journey briefly to raise Lazarus from the dead. It is because of this very public miracle that Jesus is now entering Jerusalem as a king, riding on a donkey, reminding all that David had a "royal she-mule," and Solomon was anointed as king on a "wild donkey." He is being hailed as king by onlookers, a salutation that will bring him into direct conflict with the Jewish elders and the Romans. The children and young adults

rejoice to see him, but some of the elders seem to be frowning. Note: As we will see when we examine an icon of the Crucifixion, the titulus (title bar) on his cross will declare him "King of the Jews " in Latin, Greek and Hebrew. In an Orthodox rendering of the Crucifixion we will see that the *titulus* is instead inscribed, "King of Glory." In the Orthodox tradition the body of Christ on the cross is no longer alive, his eyes are not open. He has persevered and is now properly declared, *King of Glory*.

Jesus uses a hand gesture that looks very like the angel 's hand gesture in the Annunciation icon that symbolizes locution. In this case Jesus points to his heart, meaning that for one to understand profoundly the event 's meaning one must prayerfully contemplate it in one's heart. We can see from their expressions of dismay and questioning gestures that the disciples following the donkey do not yet understand the profundity of the event.

The title of the icon, Βαϊοφόρος means the Salutation or Greeting, hailing Christ as King of the Jews.

The Ascension of Christ God (IMAGE 3/1:31)
Forty Days after Pascha (Easter)
Kontakion:
When You had fulfilled the dispensation for our sake, and united earth to heaven: You ascended in glory, O Christ our God, not being parted from those who love You, but remaining with them and crying: "I am with you and no one will be against you!"

Christ ascends in an orb or mandorla of a luminous darkness attended by angels. Below, the disciples look up to heaven, and the Theotokos opens her hands in wonder and silent prayer. She is attended by angels who were identified as, "two men in white garments." (Acts 1:10)

(IMAGE 3/1:32) In the second Holy Transfiguration Monastery icon, the Theotokos with the disciples is looking heavenward with hands raised in wonder and praise. Notice that the Theotokos because of her special status does not touch the ground, but again stands on a low platform. Also notice that the platform is depicted in "reverse perspective," i.e., larger in

the back than in the front, another iconographic characteristic more fully examined in the next chapter.

Pentecost (IMAGE 3/1:33) — fifty days after Pascha (Easter)
Kontakion:
When the Most High came down and confused the tongues He divided the nations, but when He distributed the tongues of fire He called all to unity. Therefore, with one voice, we glorify the All Holy Spirit!

(IMAGE 3/1:34) The disciples are gathered and sitting in a *synthronon*, a structure in a church combining the bishop's throne, *kathedra*, and clergy stalls placed behind the altar against the east wall, often in a curve in Eastern churches. In the center there is a space because that is where Christ would sit. Instead of the bodily Christ, spears of luminous darkness descend from heaven on the apostles, all of whom are haloed. Below, emerging from a black hole, black representing unredeemed creation, is crowned *Kosmos*, creation holding twelve scrolls indicating the preaching of the twelve disciples that will evangelize the world.

In this icon it is easier to see that the two apostles nearest to the center are Sts. Peter and Paul. Historically, of course, Paul, then Saul, was not present at the descent of the Holy Spirit on Pentecost. He was not yet a Christian, but so important is he to the establishment of the early Church that he is depicted with Peter in an exalted place on the *synthronon*.

The Dormition (Falling Asleep) of the Theotokos, August 15 (IMAGE 3/1:35
Kontakion:
Neither the tomb, nor death could hold the Theotokos, Who is constant in prayer
and our firm hope in her intercessions. For being the Mother of Life, she was translated to life by the One who dwelt in her virginal womb.

(IMAGE 3/1:36) There is a full description of this icon in the next chapter, but here it is important to point out that we see the Theotokos recumbent on her bier, surrounded by the apostles and Christ himself amid angels holding her soul, depicted as a swaddled infant.

(IMAGE 3/1:37) The Theotokos has always been regarded as a model for the praying Church, hence (IMAGE 3/1:38) the icon of the All Holy One, *Panagia*, or *Platytera* , "wider than the cosmos, " is usually placed in the apse at the east end of the church so that the Holy Mother and her Divine Son protectively "hover " (IMAGE 3/1:39) over the altar.

Note: (IMAGE 3/1:40) Nut is the Ancient Egyptian goddess of the sky and stars, the cosmic mother who "hovers " over world. (IMAGE 3/1:41) The Mother of God is also the ideal of all Christians, pure, modest, faithful, prayerful, etc. easily surpassing the bravest Girl Scout; her life held up as an example from birth to death. Here let us compare the two festal icons from Holy Transfiguration Monastery, the Nativity of the Theotokos, and the Dormition of the Theotokos. (IMAGE 3/1:42) I am certain that anyone can see the iconographic ligature that connects the icons and the events into a stunning homily on upholding a saintly, earthly life that ends by "falling asleep in Christ. " "Falling asleep, " i.e., "dormition, " is the concept properly reflected in the word "cemetery, " not graveyard or memorial park.

The English word comes from the Greek *koimeterion*, meaning "a sleeping place," or dormitory.

The Exaltation of the Cross, September 14
(IMAGE 3/1:43)
Kontakion:
As You were voluntarily raised upon the cross for our sake, grant mercy to those who are called by Your Name, O Christ God; make all Orthodox Christians glad by Your power, granting them victories over their adversaries, by bestowing on them the Invincible trophy, Your weapon of Peace.

(IMAGE 3/1:44) Empress St. Helena, mother of St. Constantine the Great is shown to the right of the Holy Cross that is held by Bishop St. Macarius. She is credited with finding and then identifying the True Cross. Pious legend has it that Helena had been searching for many days before she noticed a sweet smelling plant growing on a barren hill outside Jerusalem. Immediately, she gave instructions to dig under the plant where she discovered the True Cross. Today this plant, sweet basil, is a basic herb.

The name itself is derived from the Greek word *basileus*, meaning "king."

Often missing in the festal register of an iconostasis, are the icons of (IMAGE 3/1:45) the Crucifixion. After the Mother of God with her divine child in a variety of formulations, and the *Pantocrator*, the Crucifixion is probably the most painted icon, either by itself or part of a larger composition. (IMAGE 3/1:46) The cross is planted squarely on Golgotha which scripture tell us means "the place of the skull." Some attribute the name to the regional rock formation that may have looked like a skull. Pious tradition has it so named because it was the place of Adam's burial, hence the skull of the old Adam rests at the foot of the new Tree of Life upon which hangs the new Adam, from which a trail of redeeming blood flows over the skull of the first Adam. The skull and crossed bones of Adam have for centuries represented death, from a pirate flag to a bottle of poison, while the cross represents new life. The sun and the moon bear witness to the mystery of God suffering, but the body of Christ is already dead and at peace. No Orthodox icon shows Christ with open eyes like the San Damiano Cross, or in the throws of suffering. (IMAGE 3/1:47)

Instead, he is the Christ who has won the battle. He is "The King of Glory" as rendered on the *titulus*, the title bar over the head of Jesus. The Theotokos with three other women appears on Christ's right and to the left St. John and the centurion, who having speared Christ now utters, "This man truly was the Son of God." (Matthew 27:54) The wall in the background indicates, as the gospels tell us, that Jesus was crucified outside the walls of Jerusalem.

Pascha (Easter) (IMAGE 3/1:48)
The "feast of feasts" is so central to the liturgical life of the Church that it stands apart and its icons are frequently displayed within the liturgical space that requires movement of some kind, processional or devotional activity. The first icon of Pascha is the *Anastasis* (Raising Up) (IMAGE 3/1:49), used specifically on Saturday night, showing Christ who, after descending into the "limbo of the fathers," and breaking down the gates of Hades and binding the figure of death in chains, grabs the hands of our first parents, Adam and Eve, to raise them up to heaven along with all the good men and women of the Hebrew testaments who have been waiting in limbo for Christ to be the "first

born from the dead." (Col 1:18) (IMAGE 3/1:50)

The second Paschal icon is the Sunday morning icon of the Myrrh Bearing Women coming to the empty tomb and encountering an angel who announces that the Lord is Risen. (IMAGE 3/1:51) Both icons are properly inscribed *Anastasis*, as they are components of one mystery — The Resurrection. (IMAGE 3/1:52)

There are other feasts and commemorations that are not numbered among the traditional twelve that may or may not appear in the festal register on an iconostasis, largely dependent on the space available. (IMAGE 3/1:53) The festal register itself will be more closely examined in Chapter 4. Among these icons are: (IMAGE 3/1:54) the Circumcision of Christ (January 1). (IMAGE 3/1:55); The Visitation (September 23) (IMAGE 3/1:56); The Nativity of St. John the Baptist (June 24) (IMAGE 3/1:57); The Raising of Lazarus (Saturday before Pascha) (IMAGE 3/1:58); (IMAGE 3/1:59); Christ and St. Thomas (Sunday after Pascha) (IMAGE 3/1:60); Saints Peter and Paul (June 29) (IMAGE 3/1:61); The Beheading of St John the

Baptist (August 29) (IMAGE 3/1:62) (IMAGE 3/1:63); and The Protecting Veil of the Theotokos (October 1), (IMAGE 3/1:64)

In all narrative icons a story is told to inform and clarify the theological importance of an event in the life of Christ, that of his mother or saint(s). A beautiful example of an important narrative icon is that of The Forty Martyrs of Sebaste, a feast always celebrated during the forty days of Great Lent to enjoin the faithful to encourage one another to persevere during the rigorous period of fasting, prayer and almsgiving. (IMAGE 3/1:65) There are some variations to the pious story, but the fundamentals remain the same.

Under the Emperor Licinius, in A.D. 320, Forty Soldiers of the Garrison of Sebaste, in Armenia, bore glorious testimony to Christ. For refusing to sacrifice to idols, they were, out of hatred for the name of Jesus, thrown into prison and tortured in many ways. (IMAGE 3/1:66)

Finally, they were stripped of their clothes and exposed on a frozen lake. They asked God that the forty, who entered the lists, might be forty

to win crowns, forty being the number consecrated by the Fasts of Jesus, Moses, and Elias.

One of them, whose courage failed, threw himself into a bath of tepid water, prepared near by, and perished in it. But their guard, touched by grace from above, took his place, and there were forty martyrs, signified by the forty crowns that were seen to descend from heaven.

When they had expired, their bodies were carried away on chariots, to be burned, all except the youngest, who was still alive and whom they hoped to convert to the worship of the gods. But his mother, who, above all, was his mother in Christ, took him in her arms, followed the convoy, and when her son had breathed his last, laid him on the pyre with his brothers in Jesus.

They were thus united in death as in life, and their souls entered Heaven together. "How pleasant it is for Brethren to dwell together in unity!" (Ps 133)

Narrative Panegyric

These icons describe particular events in the lives of saints. Some, by the use of small scenes *tupoi* , singular *topos* — type, commonplace, pattern, paradigm, describing a saint's life surrounding his or her portrait, reflecting actions taken by Christ during his ministerial years. The icon may then be called a panegyric, i.e., praising the life and particular virtues of the saint as a living icon of Christ and reflecting Gospel values. (IMAGE 3/1:67) The Byzantine view of the Christian icon as a locus of encounter with holy persons and realities, and an affirmation of their continuing presence in the life of the faithful, is part and parcel of the veneration of holy icons.

(IMAGE 3/1:68) Exaggeration of an icon 's aesthetic qualities for spiritual reasons was natural to iconographers who were habitually paraphrasing and copying *tupoi*, especially scenes from the life of Christ, that gave them Theological Icons

These icons seek to visually describe a mysterious truth. (IMAGE 3/1:70) In this icon,

Christ The High Priest, offers his sacramental body and blood to his disciples, an element of the Faith that may be doctrinally affirmed, made visible though line and color showing truth as vision tied to a concrete representation.

I Am The Vine (Greek 16c) *Ampelos* (IMAGE 3/1:71) illustrating the Gospel passage: "I am the vine, you are the branches " (John 15:5); Hospitality of Abraham and Sara (IMAGE 3/1:72) , illustrating the Trinitarian nature of God in the visiting angels (Genesis 18:1 – 13); (IMAGE 3/1:73) the angel as "the Son of Man, " the Second Person of the Trinity before His Incarnation in the fiery furnace with the Three Youths. (IMAGE 3/1:74), and as the model of humility, the kenosis , Great Emptying of himself, "but emptied himself, taking the form of a slave, being born in human likeness; and being found in human form. " (Phl 2:7)

In this category a figure or figures may represent a particular characteristic or aspect of the Divine Economy. (IMAGE 3/1:75) *Angelos Megali Boulis* — Angel of Great Counsel —

again, Christ, the Second Person of the Trinity before His Incarnation.

(IMAGE 3/1:76) Finally, I offer this beautiful ivory diptych icon depicting many of the scenes we have already examined, now as an inspiring whole that moves the intellect, the heart and the soul when encountered in faith.

Chapter 4

THE GRAMMAR AND SYNTAX OF ICONOGRAPHY

The Face
(IMAGE 4/1:1) In Chapter 1 I described theosis as the union of God, in His energies, and humanity. It is this transformative unity that iconography seeks to describe in line and color. To explore how that is accomplished we need first to examine the importance of the face in iconography and then follow that with an explanation of other grammatical paradigms used, almost universally, in Byzantine-grounded iconography.

We acknowledge that the face is the singular human characteristic that defines an individual, such as St. Andrew of Radonezh. (IMAGE 4/1:2) The Greek and Russian words usually translated as "face" are respectively *prosopon* and *litso*. These we will take to mean "visage," that particular arrangement of sizes and shapes that makes a human "face" recognizable as a unique individual. What is of greater importance to us at this moment is the Russian

word *lik*, sometimes translated in Greek as έκφραση *(ekphráse* — expression), and in English as countenance. To quote Fr. Pavel Florensky, "Countenance is the actualization of the likeness of God in the face." *On The Icon*, The Prosopon Journal 8 (2009).

Each person is created "in the image," and after the Fall of our First Parents, by Christ the Redeemer recalled to the "likeness" of God, as recorded in the book of Genesis, theosis. The process begins with baptism and is properly nourished and enriched throughout one's life. The single most visible manifestation of the process is a transformation of one's face such as the face of the Archdeacon Stephen (IMAGE 4/1:3) in Acts 6:15, "And all who sat in the council, looking steadfastly at him, saw his face as the face of an angel." This recalls the shining of Moses' face (IMAGE 4/1:4) after he has encountered God. First in the burning bush and then on Mount Sinai (IMAGE 4/1:5) as recorded in Exodus, 34:29 ff., "Now when Moses came down from Mount Sinai... he did not know the skin of his face was glorified while God talked with Him," a phenomenon

repeated countless times in the hagiographies of both the eastern and western churches.

Fr. Florensky continues:
"When we actually look upon a divine likeness we rightly exclaim, 'The is the image of God,' but to say 'image of God' means that in such images is contained HIS FIRST IMAGE (Second Person of the Trinity); spiritual ascent illuminates the face like flashing lightning. It chases away the darkness and everything in the face that is still unformed and unexpressed. The face becomes a portrait that is worked from living material by the supreme art ... the art of ascesis ... with a beauty radiant from the "inner light" of man. Anyone who has approached a bearer of a blessed life has seen for himself this luminous transformation of a face into a countenance."

It is this transformed, transfigured face, (IMAGE 4/1:6) this *soma pnuematikon*, the "spiritual body," the countenance that iconography attempts to render, as the ultimate exposition of theosis .

Now, as we have established the importance and focus on the face, we may look at an expanded iconographic grammar.

Luminous Darkness
We have already identified Luminous Darkness as a metaphor for the energies of God also known as Taboric Light, rendered from a dark center to an increasingly light periphery.

Images of the Transfiguration (IMAGE 4/1:7) and the Ascension (IMAGE 4/1:8) show Luminous Darkness clearly, but other icons often employ it as an indication of heavenly intervention or communication. St. Mary of Egypt & Zosimos (Zosima) (IMAGE 4/1:9), Chinese Martyrs of the Boxer Rebellion (IMAGE 4/1:10), John the Forerunner (IMAGE 4/1:11), and the Dormition of the Theotokos (IMAGE 4/1:12). Here is an opportunity to read a bit more deeply into a particular icon, a Melkite icon, circa 1725.

At the top of the icon we see the Assumption of the Theotokos in a mandorla of Luminous Darkness, while simultaneously the apostles are miraculously returned to Jerusalem to witness

her "falling asleep. " One, however, is receiving a cloth from the hand of the Theotokos. Pious legend has it that Thomas was the last to arrive in Jerusalem after the tomb of the Virgin had been sealed. He begged to be allowed to look one last time on the face of the Mother of God, and so the tomb was opened only to find that her material body had been assumed into heaven to join the glorified body of the Divine Son. As a token there was left behind her sash, often translated as "girdle, " although the word now means something very different in English. It remained a prized relic in Byzantium.

Below we see the Theotokos recumbent on her bier. In front of the bier we see the small figure of the Jewish priest Jephonias (the impious Jew) who wanted to topple the funeral bier, but the Archangel Michael cut off his hands as he touched the bier. Jephonias immediately repented and St. Peter, standing to the left with a censer, who had cut off the ear of Malchus during Jesus' arrest, miraculously restores Jephonias' hands as Christ restored the ear of Malchus. Jephonias subsequently became a priest, some say a bishop, in the Early Church.

In the center we see the apostles and early church hierarchs, perhaps James *Adelphotheos* (Brother of the Lord — first bishop of Jerusalem), many without halos to simplify the composition, but all looking bereaved. In the very center is Christ God surrounded by angels in a crowded mandorla of Luminous Darkness, holding a small swaddled figure, the soul of the Theotokos. One is supposed to see a resonant, harmonious connection with this image and all the icons of the Theotokos holding the infant Jesus. In some icons he passes the soul of his mother to an angel who lifts it toward the mandorla in which the Theotokos is assumed into heaven. Now, look at the icon in its entirety. I believe you will remember nearly all of the story every time you look at this icon.

In this icon and others we can see the next characteristic of holy icons, shallow, raked space.

Shallow, Raked Space
There is no attempt to make the iconographic space three dimensional. Rather, all figures are moved to the front of the icon, often unnaturally suspended above one another with

no foreshortening to indicate depth. This shallow space brings iconographic characters as close as possible to the viewer.

Today many people do not understand the use of a "raked space." English theatre stages in the Middle Ages sloped upward away from the audience. The tradition continues today in some theaters. (IMAGE 4/1:13) This is known as a raked stage and improves the view and sound for the audience. The term "upstaging" refers to one actor moving to a more elevated position on the raked stage, causing the upstaged actor, who stays downstage, closer to the audience, to turn their back to the audience to address the upstage cast member.

Iconographically, (IMAGE 4/1:14) raked staging works with the same intention, to show the viewer more characters and details of a scene (IMAGE 4/1:15) as in this Entry Into Jerusalem icon, or this (IMAGE 4/1:16) icon of the Forty Martyrs of Sebaste. The purpose is not to render natural space but supra-natural space; an effort enhanced by the next subject in the iconographic canon, reverse perspective.

Reverse Perspective

There have been many attempts to explain reverse perspective as an artistic technique, but it is best understood in the larger context of the icon and the viewer. A practicing psychologist once told me that the first and most important goal for working with a patient/client was to establish a safe space between the practitioner and patient. This is accomplished by creating a quiet, confidential environment where no external distractions will disturb. It is then necessary for the two participants to explore and test the space between them. Small gestures and responses will ideally establish increasing trust and shrink that space so that intimacy is established. That is precisely what a devotee and an icon will ideally establish. Here I am speaking initially about an individual and a portrait icon, but the same can be said for a small, easily approached narrative icon, and the experience can then be transferred to all icons, even those in remote parts of a church.

The small, portrait icon illustrates this desired intimacy most easily. Old icons often are convex (IMAGE 4/1:17), taking advantage of a wooden panel's tendency to warp. To control

and limit the panel's warping, panel icons often have beveled ribs or spines inserted on the back, and linen imbedded in the gessoed front to keep paint from cracking and releasing as the icon ages. When an icon panel (and the finished icon) has a recessed square or rectangular central area it is called a Kovcheg (К овчег), the Russian word for "ark," a box or coffer in which something sacred is kept, like a sacred relic. ("An Icon Begins with Wood," Icons and their Interpretation: Information for the Objective Student of Russian, Greek, and Balkan Icons, (https://russianicons.wordpress.com/tag/kovcheg/) The outer edge of each side of the kovcheg slants up sharply to meet the raised outer border of the icon called the *polya* (Поля), field. Often secondary images of saints, angels or other figures may be found on the polya . There may be a strip of color, usually red, extending around the outer edge of the polya. This is the push, meaning "border" or "trim."

When well executed, the inner part of the icon seems to advance toward the viewer, especially on a convex surface. Again, quoting Pavel

Florensky, the icon is, "the boundary that simultaneously separates and joins " It has often been described as a window or doorway into the new creation, the eighth day of creation, but it is simultaneously a window or doorway OUT, so that the worshiper may be in contact with the divine, often the locus of wonder-working effects, healings, sweet fragrances and oils, levitations, even travels. There are many pious traditions involving the miraculous transportation of icons to places where they are needed.

Returning to the main point, the icon and the viewer are literally "made for each other." The icon does not exist to be decorative, a cultural artifact. It exists, through the hands of an iconographer, so that whoever encounters the icon has an opportunity to contact the divine. An icon scarf placed over an icon and folded so as to extend out from the icon may set it off as if it were in a small chapel. I once observed an Orthodox nun in a dark chapel approach a particular icon and with a veil cover her own head and then place the far side of the veil over an icon. In this arrangement she held a burning candle and a prayerbook in what had become a

very private, intimate chapel where she and the icon were in devoted communion.

It is with this understanding of the relationship of icon and viewer that we may turn to directly examine Reverse Perspective versus linear perspective that is common in western painting. A beautiful example is N. C. Wyeth 's 1906 illustration, (IMAGE 4/1:18) "Across The Scene Of Yesterday 's Accident. " Linear perspective (IMAGE 4/1:19) is a gift of the Italian Renaissance wherein closer objects appear larger as lines of perspective converge in three-dimensional space on the horizon. This tradition of "natural " or linear perspective continues into the modern era in Salvador Dali 's Crucifixion (Image 4/1:20), (Image 4/1:21), and is sometimes gently mocked or played (IMAGE 4/1:22) with, as in David Hockney's painting Rejecting Perspective. Reverse perspective (Image 4/1:23) is a form of perspective in which the objects depicted in a scene are placed between the projective point and the viewing plane. This has the visual effect that objects farther away from the viewing plane are drawn as larger, and closer objects are drawn as smaller, the lines are

drawn as diverging against the horizon, the point of convergence being the viewer, outside the icon in the intervening space between icon and viewer, establishing an occasion of encounter. The comparison of two renderings of The Annunciation will make the difference obvious. A classic illustration of linear or "natural " perspective is Fra Angelico's Annunciation (IMAGE 4/1:24) (IMAGE 4/1:25) where the viewer is invited into the scene. This is compared to icons of the Annunciation (IMAGE 4/1:26) where the characters of the Theotokos and the Archangel (IMAGE 4/1:27) are nearly tipped out of the frame to encounter the viewer.

It should be acknowledged that during the long history of iconography artistic influences from the Renaissance west, including the allure of natural perspective, were embraced, tolerated and established a superficial hold on iconography. This was especially true during the reign of Peter the Great (1682 – 1725) and through the Victorian era. Yet, even during the Ottoman occupation of Greece for nearly four hundred years (1453 – 1821), and seventy years of communism in Russia, classic iconography

was preserved and is once again flowering thanks to many holy iconographers (IMAGE 4/1:28), including Photios Kontoglou. Through his iconography and the training of many young artists in the techniques of Byzantine iconography, and through his long, luminous and spirited defense of Byzantine art, culminating in 1960, with the publication of the monumental two-volume work entitled *Ekphrasis*, (Expression) — the theory and practice of Byzantine iconography — Kontoglou succeeded in making Byzantine iconography the dominant mode in Greece.

Before moving on to the traditional grammar of iconography, I want to note an exception. Iconography has always rejected the three dimensional image for all of the reasons cited above. Low or "bas " relief has been able to conform to the traditions of holy iconography, but not "free standing " sculpture, with two notable exceptions. Images of St. Nicholas (IMAGE 4/1:29) and St. Nils Sorsky, (IMAGE 4/1:30) a medieval monk who brought Hesychasm to Russia. How and why these exceptions came to be is not known to me.

Halos, Gold Background (*Epichryson*), Multiple Time Events, Glowing Bodies

We have already described Luminous Darkness and Taboric Light. Following Raked Stage and Reverse Perspective we will now focus on four more obvious elements of classic iconography.

Halos

Halos predate Christianity. (IMAGE 4/1:31) Sunbeams emanated from the head of the Greek sun god Helios and were then shared by other pagan deities or would-be gods (IMAGE 4/1:32), such as Ptolemy III Euergetes. They are employed in Holy iconography and in western religious painting to identify Christ and the deified persons sharing in the immortal life of Christ God, i.e., saints. The body halo, or aureole, was reserved for Christ and the Theotokos. Infrequently a figure was given a square halo if the individual depicted was still living when the image was created, denoting an exceptional person of recognized holiness, such as (IMAGE 4/1:33) Pope John VIII in this eighth-century Byzantine mosaic fragment in the Vatican Museum. The East understands a halo to be an "aura" that surrounds a head, a

substantive shining forth of Taboric Light from one who shares the life of the Risen Christ. In an accommodation to the viewer the halo is bisected so that one may see the face of the sanctified person. Thus, when a face is seen straight on or turned to one side or another, the halo is round, facing the frontal plane of the icon. (IMAGE 4/1:34) as in the icons of St. Tychon, and by contrast the twin icons of Sts. Basil and Nicholas. (IMAGE4/1:35)

The Italian Renaissance, by seeking to render "natural " space, converted the halo into a singlet or floating disk that hovers around a sainted person 's head and is subject to linear perspective, (IMAGE 4/1:37) , turning and dipping with the attitude of the head. The identification is clear, but the intent expressed by a holy icon is disregarded. (IMAGE 4/1:38) Often halos in an icon are highly decorated, (IMAGE 4/1:39) in an attempt to visually magnify the glory of God's energies (IMAGE 4/1:40), (IMAGE 4/1:41) enveloping a sainted individual such as St. Seraphim of Sarov.

Epichryson — Gold Background

(IMAGE 4/1:42) Halos are often gently inscribed on a gold background (*epichryson*) as in The Theotokos of the Passion, indicating to the viewer that one is observing transformed, transfigured reality where saints enjoy their glorified bodies. (IMAGE 4/1:43) A gold background is not a requirement for an icon, but an artistic choice might sometimes be dictated by the availability of gold. (IMAGE 4/1:44) When not plentiful, the background is often painted with yellow ochre or similar color. In either case the gold or color is meant to indicate sanctified time and space. The individual or characters in a holy icon are depicted as existing in their glorified bodies, transformed, transfigured by God's energies. Some Orthodox traditions prefer a color such as blue, favored by some Serbian iconographers (IMAGE 4/1:45). The choice does not alter the meaning of the icon as a depiction of the glorified Christ and glorified humanity, the quality and reality of theosis . (IMAGE 4/1:46)

Multiple Time Events

As a pedagogic tool or a theatrical device to tell an extended story, a holy iconographer may

choose to condense multiple time events into one icon. (IMAGE 4/1:47) In this icon of the Transfiguration one can see Jesus leading his disciples Peter, James and John up Mt. Tabor, his subsequent Transfiguration, and then Jesus leading his disciples down the mountain while instructing them about how the Son of Man will be handed over to those who will kill him. The lesson to be learned by the apostles and us is that when Jesus is arrested and jailed it is not because his mission has been overwhelmed and defeated by the Roman authorities, but because Jesus, who has been revealed in the Transfiguration as the Messiah, Son of God, has chosen to obey the will of the Father and proceeds to his crucifixion willingly.

In the icon of God creating Adam (IMAGE 4/1:48), we simultaneously see God breathing life into Adam and bringing the animals to Adam so that he might name them, giving Adam dominion over all of God's creation.

In the icon of The Nativity of Christ God in the Flesh (IMAGE 4/1:49) we see Christ in the manger and, in the lower right, he is simultaneously being washed, a scene from the

apocryphal gospels of Matthew and James revealing that the child Jesus is subject to the frailties and necessities of human life. In the upper left the Magi are arriving from the East with their gifts, another companion of a natural timeline.

In the icon of The Beheading of the Forerunner (IMAGE 4/1:50) we see the Baptist ready to receive his martyrdom, and his head simultaneously on the platter before him.

Glowing Bodies
As was said in Chapter 3, in an icon there is no natural or material light, no cast shadows. (IMAGE 4/1:51) Divine light suffuses, infuses and illuminates all of the new creation , the transformed and transfigured universe. (IMAGE 4/1:52) This is true for every object depicted, but especially true for human bodies that glow from within, lit by the light of God 's energies. (IMAGE 4/1:53) Faces are radiant (IMAGE 4/1:54), suffused with in inner light of theosis. (IMAGE 4/1:55) Garments glow (IMAGE 4/1:56), not reflecting light but radiating Taboric light from within, part of the iconic grammar that seeks to depict the "new

creation. " (IMAGE 4/1:57) Faces are brightened with *glykasmos/pyrodismos,* red wash with a touch of yellow ochre over flesh areas. Garments and other objects are highlighted with *oziviki* (Russian), *psemmisia* (Greek), (IMAGE 4/1:58) (IMAGE 4/1:59) very light and bright marks that indicate supra-natural radiance.

Hand Gestures
A brief word about gestures is necessary. Most of the gestures in holy icons have their origin in ancient Rome and Greece, long before Christianity. They come from a quite complex hand-gesture system used by rhetoricians and orators. As a matter of public knowledge, such gestures were understood by almost everyone at the time, but they remain a cryptic language in our contemporary world.

Blessing Hand (IMAGE 4/1:60)
One of the most commonly used hand gestures depicted in Eastern Orthodox icons is a so-called "blessing hand." A specific arrangement of fingers form the letters is IC XC which stand for the first and the last letters of the Greek words Ι ησούς Χ ριστός, Jesus Christ. Thus,

the hand that blesses reproduces the Name of Jesus. When a priest blesses with this gesture he is blessing with the name of Jesus Christ. However, because this gesture comes from ancient times, it is also associated with classical oratory and means that the speaker is going to say something important, applicable to all icons of Jesus Christ and his saints.

A blessing hand can also be rendered with the index and middle figure pointed up representing the two natures of Christ, the middle finger slightly bent indicating Christ's emptying himself and becoming fully human. The thumb and last two figures join, indicating the Holy Trinity.

(IMAGE 4/1:61) A hand pointing with index, middle and little fingers indicates that the subject is speaking, locution, as in the icon of the Annunciation. It is not a sign of blessing. The Archangel Gabriel would never presume to bless the Mother of God. Instead we may take his gesture as standing for, "Hail, full of grace, the Lord is with You."

Hand over or Pointing to the Heart

(IMAGE 4/1:62) The hand-heart gesture, pointing to or resting near the heart indicates that Christ is found in the profound prayer of the heart. The gesture is found in icons of St. Seraphim of Sarov, (IMAGE 4/1:63) and many hermit saints, especially those who practiced the incessant Prayer of the Heart, the Jesus Prayer.

Chapter 5

ARTISTIC ORIGINS OF THE ICON

We have spoken about the theological origins of the icon. We know of icons from at least the middle of the fifth century as realistic representations of saints/martyrs, as in these images of (IMAGE 5/1:1) Christ of the Sinai and the (IMAGE 5/1:2) Theotokos. These, along with an icon of St. Peter (IMAGE 5/1:3) are the oldest extant icons, protected in the Monastery of St. Catherine in the Sinai, Egypt.

The iconoclastic controversy (c 721 – 843) was the catalyst that sparked profound theological reflection and definition by St. John of Damascus, St. Theodore the Studite and the Second Council of Nicaea, 787 concerning the nature and role of icons in the faith life of the Christian community. Subsequently, iconography developed as a meta-historical, stylized, idealized language that symbolically expresses the reality of a mystical world and makes the temporal world transparent to the spirit, and vice versa. Pseudo-Dionysius (fifth century) wrote, "we depict [invisible

things] . . . so that . . . we might have a veiled understanding of them."

This chapter is about the artistic origins of the icon and acknowledges some pre-Christian religious influences on the development of the icon, and perhaps on early Christianity itself. Certainly the earliest depictions of Christ rely on contemporary depictions of Mithras, Apollo and Sol Invictus. (IMAGE 5/1:4)

Primitive Revelation
Both the first man and subsequent men may have attained to divine revelation by the grace of God though their own experiences....
Because man lives in an order of grace and is directed to a supernatural destiny, it is possible that his moral experience could indicate to him a more than natural ideal, thus bringing about an implicitly supernatural knowledge of divine things. The natural and supernatural orders must not be confused, but neither are they to be separated; and all man's experiences are in a world of sin and grace. The pointers to such a revelation, arising in the life of the individual, could be preserved and developed in religious institutions and myths so that the possibility of

supernatural faith would not depend entirely on the isolated experience of the individual. Christianity thus recognizes that primitive religion may be the vehicle of true religious, even supernatural, knowledge, though such knowledge is in constant danger of being distorted or destroyed. (Gabriel Moran, "Revelation, Primitive," *New Catholic Encyclopedia* (1967), 11:446 – 48)

St. John Henry Newman explains as follows (*Essay on the Development of Christian Doctrine* (1871; rpt.: South Bend: Univ. of Notre Dame Press, 1994)
"It may be reasonable then to expect that some pre- Christian religions may, quite rightly, anticipate that which is to come to perfect expression in Christ God, even to some of the mythic language and symbolism that signifies the value and ramification of the Incarnation, e.g. the virgin birth, resurrection, and deification of humanity ... feeling also that these usages had originally come from primitive revelations and from the instinct of nature, though they had been corrupted ... and that they were moreover possessed of the very archetypes, of which paganism attempted the

shadows; the rulers of the Church from early times were prepared, should the occasion arise, to adopt, to imitate, or sanction the existing rites and customs of the populace."

And finally, St. Seraphim of Sarov (1759 – 1833): (On the Holy Spirit in the World: St. Seraphim of Sarov 1759-1833 " (July 14, 2014), *Classical Christianity: Eastern Orthodox for Today* [website], https://classicalchristianity.com/2014/07/ 14/on-the-holy-spirit-in-the-world/ (accessed 7/11/20): "Though not with the same power as in the people of God, nevertheless the presence of the Spirit of God also acted in the pagans who did not know the true God, because even among them, God found the chosen people. For instance, there were the virgin-prophetesses called Sibyls who vowed virginity to an unknown God, but not to God, the Creator of the universe, the all-powerful ruler of the world, as He was conceived by the pagans. Though the pagan philosophers also wandered in the darkness of ignorance of God, yet they sought the truth which is beloved by God. Because of this, God-pleasing seeking, they could partake of the Spirit of God."

So, we may reasonably look for pre-Christian antecedents of holy icons.

It has long been believed that Christianity owes the genesis of its early artistic history to the Hellenic influences in the Roman world during the first centuries of Christianity. In principal, I believe that to be correct. But recent scholarship has indicated that the full picture is more complex and intricate than previously believed.

The Domestic Church and its Antecedents
Romans venerated images. They were placed on coins, and statues were erected in public places and in temples. The *lauraton* (IMAGE 5/1:5) of the emperor established the juridical proxy presence of the emperor in a court of law. Like the lauraton, a holy icon is a proxy making the depicted glorified person vicariously present in the material world. St. John of Damascus tells us in *The Fount of Wisdom* (Quoted in Mike Aquilina, *The Fathers of the Church*, 3. ed.: (Los Angeles: Our Sunday Visiter, 2013), 305:
For, as Basil [the Great, ca. 330 – 379], that much-versed expounder of divine things, says,

the honor given to the image passes over to the prototype. Now a prototype is that which is imaged, from that which the derivative is obtained.

Returning to ancient Rome, ancestor verist life masks made of wax, imagines (IMAGE 5/1:6) often with connecting red ribbons showing family relationships, were displayed on the wall of the entrance hall (atrium) of a patrician Roman home, or preserved in special miniature temple cabinets, an antecedent of the icon corner, the spiritual heart of an Orthodox home (IMAGE 5/1:7). An imago (IMAGE 5/1:8) was a beautifully tinted mask made of refined beeswax, outfitted with a wig, and startlingly lifelike. When a Roman nobleman reached a certain level of public distinction he acquired the *ius imaginis*, which was the right to have a wax image made of him, an imago . The imagines were regularly the focus of sacrifices of food, oil, libations, and were sometimes illuminated by lamps. The masks were only of men, the sole exception being the Chief Vestal Virgin. When a prominent man or woman of a family owning the *ius imaginis* died, the wax images were brought out and worn by actors

during the obsequies (funeral rites), selected because they bore a physical resemblance in height and build to the men the masks represented. The veristic tradition of funerary likenesses, however, contributed to the development of realistic Roman portraiture. As we will see, in Hellenistic/Roman Egypt, the Fayum mummy portraits reflect traditions of Egyptian and Roman funerary portraiture and the techniques of Hellenistic painting Religion, Class Struggle, and the Wax Ancestral Mask Tradition's Origin and Influence on veristic Portraiture," Performing Death. *Social Analysis of Funerary Traditions in the Ancient Near East and Mediterranean*, ed. Nicola Laneri (Chicago: Oriental Institute of the Univ. of Chicago, 2007), 237 – 86.:

The tradition of ancestral wax masks (imagines) was an integral part of what it meant to be a Roman noble. Although none of these masks has survived, numerous ancient literary sources provide information about what they looked like and how they functioned in Roman society, especially in the context of funerary rites. We know, for example, that they represented males who had achieved high political office and were kept on display in the

atrium, the formal and ceremonial room of the nobleman's house, where the master received clients and friends on a daily basis and during special festivals. Serving a didactic purpose, they were intended not only to impress visitors with the prominence of the nobleman's family but also to inculcate moral and civic values in members of the family, especially young males who were expected to emulate the illustrious achievements of their ancestors to bring further distinction to the family.

On the death of a prominent family member, the wax ancestral masks were worn by hired actors, who marched in the funeral procession dressed in the garments of the highest office held by the deceased, while carrying the insignia of his political office. During the public eulogy for the dead, this entire chorus of mask-wearing actors took their seats on the Rostra (speakers' platform) in the Roman Forum, where each ancestor was eulogized in chronological order by a male of the family. The care taken to choose actors who resembled the deceased in height and general appearance underlined a basic need to revivify the dead, for in donning the mask and clothes of the

deceased, the actors took on the persona (also the Latin term for a mask) of the deceased. (John Pollini, "Ritualizing Death in Republican Rome: Memory,Religion, Class Struggle, and the Wax Ancestral Mask Tradition 's Origin and Influence on veristic Portraiture, " *Performing Death. Social Analysis of Funerary Traditions in the Ancient Near East and Mediterranean* , ed. Nicola Laneri (Chicago: Oriental Institute of the Univ. of Chicago, 2007), 237 – 86.

(IMAGE 5/1:9) In the HBO mini-series Rome, it is before the illuminated *imagines* of their ancestors that (IMAGE 5/1:10) Servilia Caepionis and her son Brutus pray, asking for strength to complete the assassination of Julius Caesar. While this scene may be somewhat imaginary, it depicts the reverence Romans had for their ancestors and the value of prayers to the ancestors who had an unspecified relationship with the gods.

It is also true that the Greco-Roman world had an affection for painting, and in particular portrait painting. Unfortunately, we know this only from the writings of contemporary historians, such as Pliny (first century A .D .),

as virtually nothing of this art has survived. We can postulate the appearance of individual painted portraits from the wall paintings of Pompeii and Herculaneum (IMAGE 5/1:11) (IMAGE 5/1:12) , and some gilt-glass portraits found in Roman cemeteries, and mosaic work from various places in the ancient Roman world such as Antioch in present day Turkey, and (IMAGE 5/1:13) Villa Erculia in Sicily, during the first to third centuries A .D .

Media
In the ancient Hellenistic world there were two prominent painting media. Encaustic warm or tepid wax plus pigment that requires quick application onto a dark background. The rapidity of the technique was often able to capture a *moment*.

Egg Tempera is pigment suspended in an egg yoke and water medium and applied to white background (gesso). It dries more slowly and allows for detailing. Both techniques were in use by portraitists, *enkaustai* employing encaustic, and *zographoi* employing tempera. Itinerant portraitists would easily have traveled

from Alexandria, the center of Hellenistic Egypt, to Fayum and other parts of Egypt.

In addition, in the Fayum portraits, which we are about to see, there are also shrouds and funeral hangings which surround a mummy, sometimes stiffened with plaster and decorated with stucco additions.

Fayum Portraits

Fayum Portraits are an extraordinary opportunity to look into the faces of a people and a civilization easily two thousand years old. They are the product of Hellenism brought to Egypt by Alexander the Great about 300 B.C. Hellenic portraiture replaced the carved masks on Egyptian mummy cases. Their placement in Fayum, southwest of Cairo, where rich verdant farm land rises to meet the desert, was an ideal place for burial and preservation. (IMAGE 5/1:14)

The veristic tradition of funerary likenesses, however, contributed to the development of realistic Greco-Roman portraiture. In Roman Egypt, the Fayum mummy portraits reflect traditions of Egyptian and Roman funerary

portraiture and the techniques of Hellenistic painting.

(IMAGE 5/1:15) It can be assumed that what we call Fayum portraits and early Christian icons existed together until the sixth century A .D . (IMAGE 5/1:16) . Christ of the Sinai, cited above, is one of the most popular eastern images for Christians in the West, perhaps part of its appeal is that it looks natural , in the manner of the Fayum portraits. Again, this is because it predates the iconoclastic controversy and the subsequent theologically-based codification that developed the classical grammar and vocabulary of holy iconography. Up until A .D . 500 the word *eikon* was used for all portraits, but by 550 eikon was principally used to denote a sacred image, and *graphis* to describe a secular portrait.

In the following chapter when we examine the use of holy icons in rituals and their placement in churches, we will encounter the importance of directional orientation. A properly oriented Orthodox church, if not impeded by finite obstacles, faces east, as did most medieval churches in the West. This orientation was not

because they looked to a holy site or city like Mecca, but because Christians worship the Risen Christ who will return from the east along with the rising sun. The great rose windows of Gothic churches were invariably placed on the east and west walls of the church to be illuminated by the rising and setting sun.

The ancient Pharaonic Egyptians were also concerned with directional orientation. The principal god of the Egyptians was Ra, the sun god. His daily rising in the sky signaled the beginning of the ritual day. The setting of the sun was understood to be a death, although temporary, signaling a passing into the underworld. Ancient Egyptians, therefore, buried their dead on the west side of the Nile, and the referred to them as "westerners ". We will encounter this same predilection in the interior iconography of a fully decorated Orthodox church in Chapter 6

(IMAGE 5/1:17) (IMAGE 5/1:18) (IMAGE 5/1:19) Enjoy these images of an ancient people, certainly the elite but not kings or nobility. These were teachers, merchants, young and old, even infants (IMAGE 5/1:20).

Frames suggest that portraits hung on walls during the life of a person, who ideally chose to have a portrait painted at the height of strength and beauty. But in the case of one who died young, a portrait of the deceased was still sought, not unlike Victorian post-mortem portrait photographs (IMAGE 5/1:21) that were popular during the nineteenth century. After one's death the portrait was then bent and shaped, (IMAGE 5/1:22) sometimes gilded, and attached directly to the mummy or to a cartonnage case, cartonnage being the ancient ancestor of papier-mâché.

Despite the Roman hairstyles and dress (IMAGE 5/1:23) (IMAGE 5/1:24), and the fact that they are attached to Egyptian mummies, the best of the portraits are still purely Greek, with their roots in the Alexandrian School (Greco/Macedonian), stressing accurate representation, creating an eidolon illusionary duplicate image, begun by Apelles in the fourth century BC, a friend and the exclusive portraitist of Alexander the Great.

(IMAGE 5/1:25) This portrait also has an inscription identifying the woman as Hermione,

a *grammatica*, a teacher. Inscriptions identifying persons will become an intimate part of holy iconography (IMAGE 5/1:26).

Euphrosyne Doxiadis in her majestic book, *The Mysterious Fayum Portraits*, (New York: Abram's Books, 1995) disputes the notion that the subjects of these portraits are principally Ptolemaic Greek Egyptians (IMAGE 5/1:27) as this portrait of a Nubian Woman makes clear. However, in Egypt the official language of Roman administration was Greek because persons of Alexandrian society were virtually all descendants of Ptolemaic Greeks. The last of the Ptolemys was Cleopatra, perhaps the granddaughter of King Mithradates of Pontus, in present day Eastern Turkey/Armenia, and an inbred line of Ptolemys originally from Macedonia.

In Roman Egypt there seems to have been a well established custom of placing painted portraits, not only of rulers but even of common people, in temples. Carrying a mask of the deceased in a funeral procession, the common Roman custom, and the lauraton as cited in Chapter 2 (IMAGE 5/1:28) or placing

an image of the emperor in official buildings such as courts, expressed the vicarious and moral presence of the emperor, and were part of the Hellenistic, Roman, Egyptian milieu. This vicarious proxy is repeated in holy iconography, as previously cited.

Some Egyptian prototypes are obscure, but should be considered, if only in passing, e.g this depiction of the (IMAGE 5/1:29) Goddess Nut (Nuit). T he over-arching protective female goddess resplendent with stars is a possible antecedent of the (IMAGE 5/1:30) apsidal icon of Theotokos Panagia who is found hovering above many, if not most, Orthodox altars. Greeks and Egyptians, perhaps all Mediterranean cultures, shared the notion that the face represented the identity of the person. Even in language the face was central. In Greek *aprosopos*, faceless one, meant a slave, one who was without "personhood ". As I have said, in holy iconography the face is of primary importance, evident in the Holy Mandylion. (IMAGE 5/1:31)

Artistic Reference

Fayum artists used a four color, tetrachrome palette inherited from Apelles, which included: Gypsum White, White Clay (Melian White), Yellow Ochre, Red Ochre (Sinoper), Lamp Black, Bone Black, Vine Black (blue-black). The Greek palette expanded to include blue Azurite or Indigo-murex from contact with both Egypt and Phoenicia. The pallet then passed into the Byzantine iconographic tradition where additional colors were employed for jewelry, garlands and clothing, and yellow ochre with white highlights to depict gold.

Fayum artists discovered that in modeling a figure, cool colors seem to recede and warm colors to advance, rather than relying exclusively on the use of chiaroscuro , the use of strong contrasts between light and dark that became prevalent in the Italian Renaissance.

Religious Pharaonic Reference

(IMAGE 5/2:1) In the Fayum portraits, as in their descendent holy icons, (IMAGE 5/2:2) eyes convey presence of divinity, notably the eye of Horus (IMAGE 5/2:3). Eyes convey life

and vitality, mortal or immortal. (IMAGE 5/2:4), (IMAGE 5/2:5) In Fayum portraits, eyes look directly at the spectator, conveying the living presence of the one depicted, a common convention in holy iconography. Fayum portraits have a vitality and animation, *energia*, that suggests an immortal spirit.

(IMAGE 5/2:6) Jewelry is consistent with worshipers of Isis, and associated gods and goddesses. One is reminded of the Theotokos wearing her three jewels (IMAGE 5/2:7) , on her brow and both shoulders, symbolizing her eternal virginity before, during and after the birth of her divine son.

(IMAGE 5/2:8) A priest of Serapis is identified by the diadem he wears. Serapis was a syncretistic deity derived from the worship of the Egyptian Osiris and Apis who also gained attributes from other deities such as the chthonic powers of the Greek Hades and Demeter, and the benevolence of Dionysus. Tradition holds that St. Mark travel- led to Alexandria and there founded the Church where he was bishop, before being martyred by priests of Serapis.

(IMAGE 5/2:9) (IMAGE 5/2:10) Pharaonic Egyptians regarded the flesh of their deities as being made of gold, so it was natural to apply gold to the portraits of those believed to now live in the realm of the gods.

(IMAGE 5/2:11) Gold leaf was added after the death of an individual pictured in a portrait. (IMAGE 5/2:12) Gilded lips possibly suggested oracular intercession and implied deification. (IMAGE 5/2:13) Wreaths of gold in the pharaonic funerary tradition indicated belief in resurrection. The Orthodox tradition of a gilt background (epichryson) likely comes from this eastern heritage shared by many cultures in the ancient East. Gilt plus gilt-stucco and arched frames also related the portrait directly to the mummy.

Fayum panels are very thin, so as to conform to the mummy and increase the three dimensionality. This reminds one of the convex (IMAGE 5/2:14), bowed (IMAGE 5/2:15) character of some holy icons, pushing the image forward.

Egyptians believed that the living could communicate with the dead, and that the dead could have an intercessory impact on the lives of the living, especially as the dead, properly cared for, shared in the life of the deities in both the Old and New Kingdoms. Busts of ancestors called "excellent spirits of Ra " were venerated in the homes of the living during the New Kingdom. Ancestors ' mummies were sometimes kept in homes and venerated as vehicles for communication with the gods.

IMAGE 5/2:16) In this romantic painting by Edwin Longsden Long, RA (1877) one sees an ancestor 's mummy case displayed at a banquet to impress guests, whose reactions are varied. Coffins, such as this one at the J. Paul Getty Museum, (IMAGE 5/2:17) sometimes had sliding doors or lids for an intimate, face to face communication with the deceased pictured in the portrait, and sometimes had inscribed prayers for the living as well as the dead.

(IMAGE 5/2:18) Sarcophagus in Greek means "flesh eater," but was called the *neb-ank* in ancient Egyptian, "giver of life, " the tomb as

womb. It was the sarcophagus/neb-ank that transported the dead into the world of the gods.

Funerary spells were believed efficacious for the dead and the living. Living members of the Egyptian elite might, by observing the proper rituals, join the company of deities while still alive (deification).

(IMAGE 5/1:19) The similarities between Hellenic Egyptian portraiture and early Byzantine painting are evident. The fundamental artistic roots of early iconography changed little until the ramifications of the Iconoclastic Controversy began the codification of holy iconography.

The entire tempera and encaustic techniques used in Byzantine iconography can be found in their original forms in the Fayum portraits. These techniques remained largely unchanged while early Christianity and the Pharaonic cult of the dead co-existed until the conversion of the Roman Empire to Christianity by Constantine the Great (A .D . 306 – 337), following the Edict of Milan in A .D . 313 and the First Council of Nicaea in A .D . 325.

Chapter 6
THE SANCTIFICATION OF TIME AND SPACE

Time in Byzantine Architecture

(IMAGE 6/1:1) Time is a part of God's creation, as recorded in Genesis. It is not an illusion, *māyā*, as believed by Buddhists; it is not constitutive of a material world that needs to be escaped with one's soul intact, as taught by all dualists and John Calvin. However, it does need to be sanctified. That is the *work* Christ came to do, and that is the work we continue as we celebrate the hours and seasons of the Christian liturgical year.

Time, like matter, is part of creation into which the Son of God chose to descend. As the hypostatic union has forever changed the nature of matter, so has it changed the nature of time: When the fullness of time had come, God sent His Son, born of a woman, born under the Law, to redeem those who were under the law, that we might receive the adoption of sons. (Gal 4:4 – 5)

Time is real, and like all of creation, has been corrupted by the Fall; but it has also been redeemed by the Mystery of the Incarnation.

Two Greek words for time are used to describe the single English word "time": *chronos* and *kairos*. *Chronos* is material time, for example, "What time is Pete's birthday party?" Answer, "7:00 p.m." *Kairos* is time as an occasion rather than an extent, for example, "Is it time for the birthday cake?" Answer, "In about ten minutes," or "As soon as Martha arrives." When used by the Fathers, *kairos* is God's time, as in "the fullness of time," not "time-less-ness," but transformed, transfigured time, eternity:
That in the dispensation of the fullness of times *(kairon)* he might gather together in one all things in Christ, both which are in heaven, and which are on earth." (Eph 1:10)

In the Orthodox Church, before entering the holy place in anticipation of a Divine Liturgy, the priest and deacon say the kairon or door prayers, one of many formulae, indicating a formal entering into liturgical time, transfigured time, eternal time. Time, history, is not to be

ignored or dismissed as irrelevant. We are not, however, to regard ourselves as trapped in linear time. As we have been reborn in Baptism into the eternal Body of Christ, so we have been born into eternity *(theosis)*. It is that truth we profess when we anticipate the Second Coming of Christ at the end of time, *chronos* . It is that truth that is visually expressed in the venerable tradition of holy icons. Icons are windows into eternity — not simply a "timeless " existence, but one in which time itself has been glorified — the kairos, "eternity," that is constitutive of the liturgy. In a homily, St. Leo The Great preaches about the "present " reality of Christmas. Edward Schileebeckx, O.P., speaks about all activities of the Christ as having an eternal component to which the faithful may be connected through the liturgy in *trans-historical time*. Therefore, in the Eucharist Christ is not re-crucified; rather, those present mystically encounter THE eternal sacrifice of Christ on the Cross.

The church is the place, and the occasion, where the past, present and future — the transcendent and material — collide and combust in the eternal, through the gift of the

Holy Spirit from the *theanthropos*, the God-Man Jesus Christ. It is in the "eternal" that humanity encounters God directly in His energies, and the original will of God, that humanity might eat of the Tree of Life and have union with God, is accomplished.

Icons, as windows into kairos, transfigured reality, are occasions of grace precisely because they connect, in a material way, the temporal and eternal realities that describe time for the Christian faithful. Holy icons connect the faithful to all of Salvation History, and they anticipate the Second Coming of Christ. They speak firmly and eloquently about the importance of time and history in the Christian Faith.

The modern Roman Liturgy is entirely linear, one part of the liturgy following another without distractions. Choirs may sing, or organists play, but the Liturgy, the Mass, continues in a straight line from the Entrance, through the Liturgy of the Word and Liturgy of the Eucharist, toward the Final Blessing and Dismissal.

The Eastern Divine Liturgy follows much the same pattern but is also multilayered, polyvalent, with multiple activities happening simultaneously. While cantors sing theologically informed chants, the deacon may instruct the congregation, "Let us pray to the Lord!" the priest may pray silently, move liturgical items; and he or the deacon may incense items and spaces.

Movement itself is an integral part of the liturgy; movement through space from narthex to *soleas* where one is fed with heavenly food, a prayer, an act of *synergia* of God's energies and an individual's energy, a recapitulation of theosis as a present and future reality, the journey of a pilgrim. In this journey icons play an integral part.

This movement from the profane to the holy has its antecedent in antiquity, especially in the (IMAGE 6/1:2) Jewish Temple ritual where a pious Jew as a pilgrim came as close to the Holy of Holies, the Tabernacle, as allowed.

(IMAGE 6/1:3) Only the High Priest was permitted to enter the inner sanctum once a

year to offer a sprinkling of blood, the sin offering on the mercy seat, and the offering of incense. A pious legend, with obscure beginnings in the Middle Ages, held that he was tethered by a rope fastened around his ankle so that should he be slain by the power of God, his body might be retrieved from the sanctuary. Now refuted, the legend still indicates the importance of proximity to the seat of God's presence.

(IMAGE 6/1:4) Structured on the axial movement of a pious Jew to and through the Temple in Jerusalem, an Orthodox church first encourages axial movement, then vertical ascent.

(IMAGE 6/1:5) For the Eastern Christian there is a similar appreciation of pilgrimage. We live in a profane world. The word "profane" comes from the Latin, *profanum*, and here does not mean filthy, blasphemous or coarse. Rather it means the world known through the senses; it is the natural world of everyday life that we experience as either comprehensible or at least ultimately knowable. In the sacred, sacrum in Latin, encompasses all that exists beyond the

everyday, natural world that we experience with our senses. As such, the sacred or numinous can inspire feelings of awe, because it is regarded as ultimately unknowable and beyond limited human abilities to perceive and comprehend.

The pilgrimage begins in the exo-narthex of a church, the porch outside the portal, if there is one. In some Greek churches with an exo-narthex, the first space after the front door may be decorated with icons of ancient philosophers such as Socrates, Plato and Aristotle (IMAGE 6/1:6) who genuinely sought God before the Incarnation. These can be seen especially in northern Greece in places like Ioannina and even Mount Athos, at Vatopaidi, and the Great Lavra. They can be seen prior to entering the nave of the church. The Hermenia or Painter's Manual (Great Neck NY: Oakwood Publishing, 1989).by the Monk Dionysius of Fourna (A.D. 1670 – 1745) mentions the names, descriptions and quotes of various philosophers to guide iconographers toward their correct depiction.

(IMAGE 6/1:7) During the Ottoman occupation (fifteenth to nineteenth centuries) many

churches and monasteries throughout Greece served as "secret schools," κρυφό σκολειό, where the writings of the ancients were studied in a private environment and taught by either monastics or clergy. (IMAGE 6/1:8) Often these schools were in the exo-narthex of churches, which is why icon frescoes of ancient philosophers and writers are often found in this area of the church. Because many of them are said to have foretold the coming of Christ as well, they were revered by Christians for their wisdom, though not as saints, hence their depiction without halos.

(IMAGE 6/1:9) For the Eastern Christian the spiritual pilgrimage is begun in the exo-narthex, the profane world, continues into the narthex or entry-way of the formal church, properly the place for penitents and the unbaptized to view through open doors the Liturgy of the Word. The faithful, the baptized, proceed through the doors into the nave, the central part of the church, in Latin *navis*, in Greek *naos* (ναός), "ship," recalling Noah's Ark by which humanity was protected and saved by God.

Once in the nave of the church the Eastern Christian is not expected to sit during a service. The usual posture is to stand, following the instruction of St. Basil who taught that standing was a sign of one's dignity as a child of God redeemed by Christ. Hence, in a Byzantine Catholic or Orthodox church, especially in the old world, there are no pews or chairs, except perhaps against the back wall of the nave, where seating for the elderly and infirm, often backless benches, may be found. Churches were not furnished with permanent pews before the Protestant Reformation. The rise of the sermon as a central act of worship in Protestantism, made the pew a standard item of church furniture.

Having entered the *naos*, nave, the Eastern Christian is immediately in the company of icons: martyrs, soldiers, prophets, confessors, male and female saints. Some icons may be freestanding with candle holders, some may be close to parishioners so that they may be kissed. The variations are numerous; but in all cases the icons populate the church. The Church Triumphant meets the Church Militant to strengthen and inspire.

There are multiple and sometimes conflicting interpretations of an Orthodox church and its various sections. Two of the most influential interpretations of a church interior are the Antiochian and Alexandrian, reflecting the histories of two of the five great patriarchates. Both, however, embrace the ascendent character of the church from the square earth to domed heaven, that will be explored shortly.

(IMAGE 6/1:10) The Antiochian Model interprets the Divine Liturgy in a scriptural-historical representation of the Life of Christ. As an example, the silent prayer of the priest as he covers the gifts of bread and wine with the aër (veil) after their procession during the Great Entrance, and their placement on the holy table, the altar:
"The noble Joseph, taking down your spotless body from the wood and wrapping it in a clean shroud with aromatic spices, carefully laid it in a new tomb."

(IMAGE 6/1:11) The Alexandrian Model is an alle- gorical interpretation of the Divine Liturgy, a s in the priest's prayer:

"We thank You also for this Liturgy which You are pleased to accept from our hands, though there stand before You thousands of archangels and myriads of angels, cherubim and seraphim, six-winged, many-eyed, soaring on their pinions; singing, proclaiming, shouting the hymn of victory and saying, Holy, Holy, Holy Lord of Hosts: heaven and earth are filled with your glory. Hosanna in the highest. Blessed is he who comes in the name of the Lord. Hosanna in the highest."

And in the Cherubic Hymn, sung by the entire congregationand choir during the Great Entrance:
"We who mystically represent the cherubim, and sing to the Life-giving Trinity the thrice Holy Hymn."

The Church of the Monastery of Stavronikita on Mount Athos, which we will explore more carefully at the end of this chapter, was painted by the idiorythmic monk Theophanes of Crete and his family during the early sixteenth century. It is of particular interest to those studying iconography because it was entirely programmed and painted by one man and his

sons, and is therefore a unified iconographic jewel. In 1204, in the aftermath of the Fourth Crusade, Crusaders sold the island of Crete to Venice, which fitted it into its growing commercial empire. The native Cretans, however, never abandoned their Orthodox religion, Greek language, and popular lore. The Ottoman Turks, who were already in control of parts of Crete, wrested the capital city of Candia, now Irákleio, from the Venetians in 1669 after one of the longest sieges in history. It is also interesting to note that as Theophanes was from Crete there is a Renaissance "gloss" to his iconography that makes it more accessible to western eyes. His iconography is entirely "orthodox," but some naturalness attends the figures.

(IMAGE 6/1:12) In the quintessential orthodox decoration of a church interior the beginning ground level has military saints and above them martyrs, male and female saints, and above them scenes from the ministerial life of Christ running clockwise around the church. We will more fully appreciate the placement of various icons when we examine the interior of the church.

To more fully appreciate the place of holy icons in an Eastern church, one must understand their placement within the architecture that is itself a metaphor of the spiritual journey of each individual. The great patriarchal cathedral of Hagia Sophia, Holy Wisdom, in Constantinople (IMAGE 6/1:13), built by the Emperor Justinian in the sixth century, became the model for most Orthodox churches. (IMAGE 6/1:14) It remained the world's largest cathedral for nearly a thousand years, until the Seville Cathedral, Santa Maria de la Sede , was completed in 1520.
(IMAGE 6/1:15) The plan for Hagia Sophia is called a cross-in-square, (IMAGE 6/1:16) with equal arms north, south, east and west. The *bema* , sanctuary or holy place , is in the east. This basic form is different from the basilica plan (IMAGE 6/1:17) that was prominent in the West, the outline of which is a Latin Cross with a long nave and a north-south transept crossing, and the sanctuary in the east.

A cross-in-square church (IMAGE 6/1:18) is centered around a quadratic *naos*, nave, which is divided into nine bays by four columns or piers. The central bay is usually larger than the

other eight, and is crowned by a dome which rests on columns. The four rectangular bays that directly adjoin this central bay are usually covered by barrel vaults; these are the arms of the cross which is inscribed within the square of the *naos*. The four remaining bays in the corner are usually groin-vaulted. The spatial hierarchy of the three types of bay, from the largest central bay to the smallest corner bays, is mirrored in the elevation of the building; the domed central bay is taller than the cross arms, which are in turn taller than the corner bays.

To the west of the *naos* is the narthex, or entrance hall, usually formed by the addition of three bays to the westernmost bays of the *naos*. To the east stands the *bema* , or sanctuary, often separated from the naos by an iconostasis. The sanctuary is usually formed by three additional bays adjoining the easternmost bays of the *naos*, each of which terminates in an apse crowned by a conch, a half-dome. The central apse is larger than those to the north and south. The *bema* is sometimes divided into the central part with the altar, while the northern section is known as the *prothesis* and the southern as the *diakonikon*.

The Square and the Circle (Dome)

Here we need to make clear the importance of two main shapes that describe an eastern church, the square and the circle. The square is traditionally associated with the material world with its four points of the compass, the earth: "After this I saw four angels standing at the four corners of the Earth, holding back the four winds of the Earth to prevent any wind from blowing on the land or on the sea or on any tree."(Rev 7:1)

And four rivers flow from Eden defining the earth: the Pishon, Gihon, Chidekel (the Tigris), and Phirat (the Euphrates), (cf. Gen 2:10 – 14). It is also associated with God's footstool: "Heaven is my throne, and the earth is my footstool." (Is 66:1)

The circle becomes the dome and is settled upon the four Evangelists painted on the pendentives, the four main pillars which literally hold up the dome of the church. Domes and tent-canopies are associated with the heavens in Ancient Persia and the Hellenistic-Roman world. A dome over a square base reflected the geometric symbolism of those

shapes. The square represented the earth, the circle, dome, represented perfection, eternity, and the heavens. The altar in some large churches is under a ciborium (κιβώριον), usually a structure with four columns and a domed canopy. (IMAGE 6/1:19)

The dome finds its human analogical equivalent in the particular spherical shapes of certain crowns, like the Orthodox bishop's miter, (IMAGE 6/1:20) which emphasize how the round human head is analogous to Heaven itself, the source of mind and logos, the principle of the body (Col 1:18). The body with its four limbs can be seen as analogous to a square.

Now we can see the pilgrim's path in its fullness. The faithful Christian moves from the profane world outside the church, through the narthex of the penitents, into the safety of the nave, *naos*, then to the *solea* where heaven and earth meet. The priest emerges from the *bema*, through the holy doors, under the icon of the Mystical Supper, to offer communion under the watchful eye of the icon of Christ Pantocrator in the dome of the church, representing the

heavenly sphere that is the final goal of every believer: to be raised up from the earth to union with God in heaven.

Having made our own pilgrimage from the first chapter of this book to last chapter, let us now conclude by looking at one of the most central elements of an eastern church, the iconostasis, and then photos of Stavonikita, appreciating the painting and disposition of the holy icons rendered by the hand of Theophanes of Crete.

The Iconostasis
(IMAGE 6/1:21) As we discuss the iconostasis, please understand that there are many variations, often prescribed by the size and history of a church. Icon tiers are sometimes reversed and various icons substituted for others. The following, however, is a solid foundation for examining iconostases in most Orthodox and Eastern Catholic churches.
The iconostasis began as an altar rail separating the nave from the sanctuary. Like the rood screen in the west, it grew in height, but unlike the rood screen it became a screen for holy icons as they became an increasing focus of Eastern piety.

There are two principal models for an iconostasis, the Greek and the Russian. We will first look at the simpler Greek model, then the Russian, which is usually higher with additional tiers or registers of icons.

(IMAGE 6/1:22) The Greek iconostasis is traditionally shorter than the Russian. On the first level, usually one or more steps up from the nave level, one finds in the center the Holy Doors, the central double doors, which are considered to be most sacred. They may only be entered at certain sacred moments during the services by ordained clergy, deacons, priests, and bishops. Properly, these Holy Doors are called the Beautiful Gate because Christ passes through these gates during the Great Entrance at the Divine Liturgy and when communion is distributed to the faithful. Sometimes the Holy Doors are erroneously called the "Royal Doors," which in antiquity were an entrance between the narthex and the nave, used only by the Emperor. Beautiful Gate is the only term used in Greek. In Russia, they are sometimes referred to as the Red Gate, red and beautiful being the same word in Russian.

(IMAGE 6/1:23) The typical gate consists of two hinged doors. The doors themselves are made of wood or metal and usually have an icon of The Annunciation in the form of a diptych, the Theotokos on the right door, and the Archangel Gabriel on the left, either alone or with icons of the four Evangelists. The doors may be intricately carved and gilded, and are almost always topped by a cross.

Theologically the Holy Doors represent the gates of Jerusalem, through which Christ entered on Palm Sunday. They also represent the entrance to the Heavenly Jerusalem. Only clergy are permitted to go through the Holy Doors, and only when prescribed by the liturgical rubrics.

During Bright Week, the week following Pascha, the Holy Doors remain open the entire week symbolizing the open Tomb of Christ. The *Epitaphios*, the textile icon representing the burial shroud of Christ, is visible on top of the Holy Table (altar) through the open Holy Doors as a witness of the Resurrection.

On either side of the Holy Doors are an icon of the Theotokos, on the left, most often The Directress, and on the right an icon of Christ, one of a variety of images. (IMAGE 6/1:24) Above the Holy Doors is usually an icon of the Mystical (Last) Supper. To the left and right of the icons of the Theotokos and of Christ are the Deacon Doors, or Angel Doors through which the deacons exit or enter the *bema*, the Holy Place. These doors are frequently decorated with icons of sainted deacons or of archangels, whom the deacons represent when standing in front of the iconostasis leading the choirs of angels, the congregants, in singing.

Flanking the Deacon Doors are usually icons of local or important saints, especially the patronal icon of the church or the saint(s) whose relics reside in the altar.

Above the Holy Doors and the Mystical Supper one most often finds an icon of the *Deisis,* (IMAGE 6/1:25), exemplified by this stunning mosaic in the great cathedral of Hagia Sophia in Constantinople (Istanbul). It is not over Holy Doors, which no longer exist, but in the imperial enclosure of the upper galleries.

In the most restricted, formal sense, a *Deisis* is an icon with three or more figures, the center being Christ of the Second Coming. He is often seated on a throne, flanked by the two standing figures of the Theotokos (Mother of God) on his right (Ps 44:10), and St. John the Forerunner (Baptist). Both are in a posture of supplication and with hands raised and heads bowed, but with an élan , enthusiasm, that gives the composition movement, especially in a larger, (IMAGE 6/1:26) developed *Deisis,* as in this sixteenth-century Russian *Deisis* or *Tchin*, meaning "order". The harmonious silhouettes of the figures suggest an ethereal wind, the Holy Spirit, gently inclining the figures like sheaves of wheat toward the center.

The *Deisis* or *Tchin* is then the central, and some would say the most important, section or register of the icon screen or iconostasis in an Eastern Church.

This central placement immediately suggests its artistic, theological and liturgical importance. To understand its importance we will first briefly examine the *Deisis* itself, then the significance of the individual figures, its

relationship to other icons, and finally its importance to us, the Christian People, as it directs and confirms our proper relationship to God.

(IMAGE 6/1:27) The format of the *Deisis* — developed or not — reflects the court life of the Byzantine Empire. Growing out of the imperial courts of Ancient Rome and the Middle East, with counterparts in the Medieval West, Byzantine court life was complex, intricate and relied heavily on symbol and gesture.

Above the *Deisis* we see the First Register or tier across the entire iconostasis, but constrained by the size and height of the church. It is the Festal Register, with icons of the great feasts of the church, as previously discussed, either in historical or canonical order. Almost without exception, however, the first icon is that of the Birth of the Theotokos, and the last iconic that of the Dormition of the Theotokos, although it may be followed by the Exaltation of the Holy Cross icon. In a Greek Church the iconostasis is topped by a central cross. (IMAGE 6/1:28)

The Russian iconostasis is principally the same as the Greek except that the Deisis appears directly above the Holy Doors and above it is the Festal Register, (IMAGE 6/1:29) which we have discussed . Above that register there is the Prophetic Tier in the center of which is an icon of the (IMAGE 6/1:30) Theotokos of the Sign. She is in a posture of prayer with the Christ Child imposed on her breast, fulfilling the prophecy of Isaiah 7:14:
"Therefore the Lord Himself will give you a sign: Behold, the virgin shall conceive and bear a Son, and shall call His name Emmanuel."

On either side of the Theotokos are depicted the Hebrew prophets who foretold the birth of the Messiah.

Above the Prophetic Register is the Patriarchal Register with the Hebrew Testament Patriarchs who anticipated the Messiah, in the center of which is most often the Holy Trinity (IMAGE 6/1:31) depicted as the Three Angels who visited Abraham and Sara. This famous icon by St. Andrei Rublev shows the Trinity without depicting God the Father which is traditionally prohibited. Iconographers have found ways

around the prohibition, e.g. painting the Pantocrator with white hair and beard and an eight pointed halo, indicating infinity, and naming him, Ancient of Days. The canonically correct way is to depict the Hebrew Testament angels.

Stavronikita

We are at the end of our short journey. As we look at of Stavronikita monastery I hope your eyes will now appreciate the holy icons shown *in situ* with some understanding of their tradition and place in Eastern Christianity. I will point out some facts in various photos, but will leave the rest up to you to discover as you move through this lovely monastery.

(IMAGE 6/2:1) There are many legends concerning the founding of Stavronikita. According to one legend the monastery was founded in the tenth century as the Haritona Monastery. According to another legend, two monks, Stavros and Nikitas, made their cells there, giving it its name. About 1530, a monk, Gregory, purchased the cells of the early monastery from the Philotheou Monastery.

Over the next several years, abbot Gregory began rebuilding the monastery. With the help of Patriarch Jeremiah I, the *katholikon*, large liturgical space, was built between 1527 and 1536 and dedicated to St. Nicholas.

The structure of Stavronikita follows the traditional Athonite form with the *katholikon* situated in the center of the enclosed monastery space. Stavronikita has the pronounced shape of a fortress. The refectory is on the first floor of the southern wing. Six chapels are located both inside the monastery as well as outside. The frescos in the *katholikon* and the rest of the monastery date from the early sixteenth century and are the work of the Cretan painter Theophanes and his son, Simeon.

(IMAGE 6/2:2) We begin with the icon above the altar. It is the Panagia Platytera (Παναγία Πλατυτέρα) — "all- holy, more spacious" — also know as the Theotokos of the Sign, previously explained. I choose to start here because it is not the most visible of icons as it is in the apse behind the holy table, altar. The Mother of God hovers over the altar, a sign of God's abiding love for His Church. The

presence of the Theotokos embodies and sustains the praying church where the Mystery of the Incarnation will be made sacramentally, mysteriously present in the Eucharist. Appropriately, below the Panagia, is the icon of the Mystical Supper where the Eucharist is instituted by Christ.

Now we move into the *katholikon*, the *naos* or nave of the church, called the *Katholikon* (Καθολικόν) because it is where the complete (catholic) monastic community gathers to celebrate the major feast days of the liturgical year.

(IMAGE 6/2:3) First is a view of the east wall with the iconostasis. Note the two renditions of The Annunciation, the first in the top section of the Holy Doors, the second on the upper left and right on two of the main pillars. Here, the icons speak to each other across a divide, sanctifying the space between.

(IMAGE 6/2:4) Opposite the east side is, of course, the west wall. You will remember that various cultures have considered the west to represent death, as it is the compass point of the

setting sun. The same is true in this church. (IMAGE 6/2:5) Directly above the door we see the icon of The Unsleeping Eye with the Theotokos gently covering or uncovering the child Jesus who seems to sleep. The point of the icon of The Unsleeping Eye is that God never sleeps, even though He may appear to, even when as human beings we encounter death. The primary prophecy related to this icon comes from the Prophet-King David, himself an ancestor of God, who foretold, "Behold, He shall not slumber nor shall He sleep, He that keeps Israel.

The reason that this icon is traditionally placed above the west door of an Orthodox Church comes from the latter portion of the same Psalm, "The Lord shall keep thy coming in and thy going out, from henceforth and for evermore." (Ps 120)

(IMAGE 6/2:6) Above The Unsleeping Eye is the icon of The Dormition of the Theotokos, previously described, with the Risen Christ holding the swaddled soul of his mother. To the right is the Risen Christ's appearance to Mary

Magdalene, and to the left his appearance to the disciples at Emmaus (IMAGE 6/2:7).

(IMAGE 6/2:8) The North wall shows military saints guarding the faithful who gather in the *naos*. To the upper right is found The Exaltation of the Holy Cross featuring the Empress Helena, mother of St. Constantine the Great, and Patriarch Macarius. She is credited with having discovered the Life-giving Cross in Jerusalem. To the right is the icon of the child Jesus teaching in the Temple (IMAGE 6/2:9).

(IMAGE 6/2:10) The South wall again shows military saints, (IMAGE 6/2:11) and above on the left (IMAGE 6/2:12) the Second Council of Nicaea. The Seventh Ecumenical Council ruled against the iconoclasts and reaffirmed the use and sanctity of Holy Icons. (IMAGE 6/2:13) The South East shows massive chandeliers and other hanging lamps. The South West (IMAGE 6/2:14) shows the Abbot 's *kathedra*, throne, and at the top Jesus and the Samaritan Woman (Photini) at the well.

(IMAGE 6/2:15) Now it is time to look up, and we see The Christ Pantocrator, The Almighty

(IMAGE 6/2:16), in the dome, with the two inscriptions I C X C (Jesus Christ) and on the halo, ό 2 ν (The One Who Is, I AM), Exodus 3:14. (IMAGE 6/2:17) Another view of the dome shows us the Holy Mandylion on the drum of the dome, (IMAGE 6/2:18) reminding us of God's eagerness to share His image with us so that we might better know and love Him.

(IMAGE 6/2:19) In the Holy Place, *bema,* and behind the holy table, altar we find icons of the two major authors of the Divine Liturgy as practiced in eastern churches, St. John Chrysostom on the left, and St. Basil on the right, and other hierarchs (IMAGE 6/2:20) . Fathers of the Church (IMAGE 6/2:21) appear in various places, and the (IMAGE 6/2:22) First Ecumenical Council, confirming the abiding presence of the Holy Spirit in the guidance of the Church through its hierarchs and councils.

(IMAGE 6/2:23) On the barrel vaults of the transepts or narthex and other upper register spaces we can see scenes from the Hebrew Testament, such as David preceding the Ark of the Covenant and (IMAGE 6/2:24) Solomon

and the Temple. Also found there are New Testament scenes from the life of Christ, (IMAGE 6/2:25) including the Mystical Supper and Christ washing the feet of his disciples, (IMAGE 6/2:26) and the Ascension of Christ.

(IMAGE 6/2:27) And finally, we return to the *bema*, the Holy Place, to see Christ distributing to his disciples the consecrated elements of the Eucharist: the bread that is his body, and the wine that is his blood. Here is the source and summit, the central mystery (sacrament) of Orthodox, Catholic Christianity. What a fitting way to end this short, and admittedly superficial examination of the profoundly gargantuan tradition of Holy Icons.

www.ingramcontent.com/pod-product-compliance
Lightning Source LLC
Chambersburg PA
CBHW032010170526
45157CB00002B/631